THE ART OF LOVE

To James Bryan

Thanks for giving me my own great love story

First published in 2019 by White Lion Publishing,
an imprint of The Quarto Group.
The Old Brewery, 6 Blundell Street
London, N7 9BH,
United Kingdom
T (0)20 7700 6700
www.QuartoKnows.com

Text © 2019 Kate Bryan
Illustrations © 2019 Asli Yazan

A catalogue record for this book is available from the British Library.

ISBN 978 0 7112 4031 5

Ebook ISBN 978 0 7112 4032 2

10 9 8 7 6 5 4 3 2 1

Design by Isabel Eeles

Printed in China

THE ART OF LOVE

The Romantic and Explosive Stories Behind Art's Greatest Couples

Kate Bryan

WHITE LION PUBLISHING

Contents

Introduction

I have always believed that artists are special. It is rare that a person commits themselves to a life of pure creative expression, governed only by their artistic impulses and motivated by the compulsion to create. It can often make for insecurities or, conversely, large egos as well as a fusion of work and life that is atypical to most people. An artist does not just make artwork; in many respects they *are* their artwork. As such, it is especially unusual and intriguing when two artists come together in a romantic relationship – often resulting in the doubling of egos, insecurities and passion.

I have always found the subject intriguing, particularly when two artists who are involved or married collaborate on their artwork. One cannot help but wonder if they ever get a moment off. How can they build a side door into a robust creative landscape that they share and cultivate? The longevity of the romantically linked artistic duo is also extremely vulnerable – what happens when love fades and two artists remain joined under a moniker but no longer by the heart? For artists in a relationship who work independently, there is a myriad of issues to navigate: how to manage jealousy and competition; how to share in your partner's work without compromising your own; whether to promote your spouse to your collectors and gallerists. And if you should both become successful in your lifetime, which as *The Art of Love* demonstrates is exceptionally rare, how do you protect your relationship and art from the spotlight of personal enquiries?

The latter point feeds into an issue that hovers around this book that I think should be addressed: biography. These essays employ a particular kind of biographical approach, focusing on how romantic relationships have defined and influenced some of the greatest artists of the past 140 years. Biography has been in and out of fashion in art history and is generally viewed as a double-edged sword. It allows us into a person's life and opens up their world to tell a very specific slice of history: the world as lived through the lens of one person. People are interested in other people; today's fetishes for trashy magazines and Instagram posts are like drops of water feeding an insatiable thirst for what is essentially biography and autobiography. We want to see the world through other people's eyes, to understand them better by knowing their circumstances. Even the everyday and mundane seem appealing when they are happening to someone else. It is especially interesting when it is happening to an artist, a person who traditionally sits outside the 'normal' spectrum of society. The biography of an artist is a fascinating insight into a life of creativity, revealing their temperament, attitudes, relationships, travel, rivalries, studio particulars and the circles they

move in. All of this can form a substructure that helps us better understand their work. For example, Picasso's paintings are often dated to the day and are as close to an autobiography as you could wish for. They are a physical manifestation of his interior world at a particular moment, revealing his mood, infatuations and influences. To know his life is to better know his paintings.

There is a danger to artist biography though. Reliance on external sources can distract from the principal concern: art. We run the risk of dampening the vitality, magic and spirit of truly great art if we explain it away by facts and psychological assumptions. We want true art to stand apart from its creator, to exist as a cultural treasure that has a value unique to us, the viewer, free to cherish, respect or critique it of our volition. Knowing that Picasso is a narcissist and philanderer and enjoyed mentally tormenting people might not help the appreciation of his work. Indeed, the circumstances of an artist's life can be an active deterrent to their work being appreciated, seen acutely in the difficulty of being a woman artist, or even worse, a woman artist married to a famous male artist. In her lifetime, Lee Krasner was never known first and foremost as a painter. She was either Jackson Pollock's wife or his widow, and she was always a 'woman' artist, rather than simply an artist. Her biography has side-lined her art in a spectacularly unfair fashion and it is still a curse even in our supposedly more enlightened times.

There are several other examples in this book of revisionist history, which looks again at an artist and attempts to untangle their work from a messy reputation, to reinterpret their significance and contribution to art from a less prejudiced position. Alongside Krasner, Elaine de Kooning, Kay Sage, Gwendolyn Knight, Sonia Delaunay and Nancy Holt have all suffered from what I call 'little wife syndrome'. They have for too long remained cast in shadow by the giant cultural standing of the men they were in love with. The chapters dedicated to these relationships address this issue and attempt to validate their significance without undermining how central and formative their relationships were. Both Krasner and de Kooning insisted they would not have had things any other way. The world may not have been able to accommodate their talent alongside their husbands', but that does not mean they wish they had fallen in love with someone else.

Happily for other 'women' artists in *The Art of Love*, the redrafting of their stories is altogether unnecessary – and testament to their remarkable influence in a period of structural and institutional sexism. Lee Miller is a great example of how many of the stories in this book call into question the notion that the women in these relationships were merely muses. I have attempted

to unravel the long-standing opinion that a muse cannot also make art or that a mistress is naturally always a muse. Picasso was well known for his lifelong romantic exploits and conquests and had at least three relationships with artists. I chose to focus on Françoise Gilot because she refused to be his muse, insisting any work that related to her was devoid of her name in the title. She knew it was compromising for her own artistic integrity. Marcel Duchamp said that in the surrealist movement women were permitted only to be a '*muse, model or mistress*', a serious condemnation of the sexist nature of the movement and the binary gender roles it subscribed to. His own mistress, Maria Martins, was his muse, but she was also an independent artist he respected, and had all the power in their affair.

Georgia O'Keeffe – wife and muse of Alfred Stieglitz – is a staggering example of a woman artist who achieved fame and recognition in a male-dominated arena. She refused to take part in Peggy Guggenheim's landmark exhibition '31 Women', as she simply did not see herself as a woman artist. It is interesting to note here that many of the women artists in this book were included in the New York show of 1943, which saw Guggenheim criticised for simply selecting the wives of male artists that she already knew without undertaking due diligence and creating a truly unbiased platform. O'Keeffe continually refused to exhibit in all-women shows and found widespread fame during her lifetime. Her reputation today far outshines that of Stieglitz, who at the time of meeting a young O'Keeffe was an established and well-respected gallerist and photographer. Likewise, when young Frida Kahlo met Diego Rivera he was the most famous artist in Mexico. Now, 65 years after her death, Kahlo is one of the most instantly recognisable and beloved artists globally. Today, Barbara Hepworth (also loath to be considered a woman artist) also enjoys a far stronger reputation globally than her husband Ben Nicholson.

The marked difference in the experiences of these women feeds into another key aspect of this book: the peculiarities of love – its unpredictable nature, the unlikely pairings it conjures, the forcefulness of it to both create and destroy. There are many strange couples in this selection, people whose personalities and preoccupations seem entirely at odds with one another. Carl Andre and Ana Mendieta are probably the most striking example: the minimal rationalist who married an earth mother expressionist. Also unlikely are Yayoi Kusama, the free-spirited woman in her 20s who painted naked bodies during 'happenings' and wanted to take the message of free love everywhere, and the much older reclusive lifelong virgin Joseph Cornell, who

could not sever ties with his mother's apron strings, let alone attend an orgy. As a fellow recluse who hated the niceties of the art world, Duchamp was also seemingly a strange match for Martins, a gregarious social whirlwind married to an ambassador.

In addition to unlikely pairings, *The Art of Love* shines a light on the many forms relationships take. Artists have long been derided, championed and forgiven for their bohemianism and liberal attitudes towards love and sex. Kahlo and Rivera famously treated monogamy as something that did not apply to their marriage. Their divorce, which lasted a year, ended with them agreeing to marry again under the condition that in future their marriage would be better if it were sexless. Elaine and Willem de Kooning had what most people would describe as an open marriage; after finally splitting up, they reconciled nearly 20 years later. Also living apart and enjoying other lovers were Jean Tinguely and Niki de Saint Phalle. Although they never separated, theirs was a love best enjoyed at a distance. Dorothea Tanning and Max Ernst treated the institution of marriage with cool detachment: their wedding was forgettable and perfunctory and Ernst never called Tanning his wife – a word he felt would put her in his shadow.

An early title suggestion for this book, *Crazy in Love*, played upon the explosive qualities of two creative souls locked together. As both individuals and artists, Tim Noble and Sue Webster have managed to survive the fallout of an intense relationship where love burnt itself out. Marina Abramović and Ulay are only now reconciling after two decades of silence, during which furious romance turned to hatred. There are many stories of artists being driven to the brink of madness by their love for another artist: Man Ray supposedly threatened Lee Miller's possible suitors with a gun after she left him. And there are plenty of stories that end tragically. Camille Claudel was driven to paranoia and mania after ending her unhappy affair with Auguste Rodin and died in truly sad circumstances. Of all the artists to die too young, Jackson Pollock occupies the largest legendary status, having killed himself and a passenger while driving drunk. When Pollock died, he had not painted for over a year, whereas Mendieta died fighting with Andre aged only 37, just as her career was taking off. Lili Elbe passed away having relinquished her former painting career in pursuit of transitioning further into womanhood, and her great love, the artist Gerda Wegener, having behaved so admirably in difficult circumstances, died penniless and alone.

Alternatively, this book presents happy stories of true soulmates: artists who found a mirror image, a person with whom they could share and develop

their burning creativity and passions. Ethel Mars and Maud Hunt Squire found not only an artistic peer with one another, but also a secure, stable, loving relationship in an age resistant to same-sex female partnerships. As a couple, they were better equipped to seek out liberal-minded folk and settle into artistic communities. Nancy Holt and Robert Smithson were locked into land art together, charting new territory, and they would no doubt have enjoyed many more years of marriage and parallel creative exploration had Smithson not died so young. Nancy Spero and Leon Golub were the original activist artists, each creating angry, powerful, honest work outwardly while maintaining an internal peace and respect within their long marriage. Anni and Josef Albers, two great disciples of the Bauhaus, spent many happy decades together in a life firmly committed to a shared belief in purity, abstraction and the power of art education. Alexander Rodchenko and Varvara Stepanova were comrades in love and art, who enjoyed a healthy, collaborative and fundamentally equal relationship decades before the women's movement in the West. In a marriage set against the backdrop of Dada, Hans Arp and Sophie Taeuber-Arp were each other's greatest champions, and when Sophie's life was cut short, Hans dedicated himself to preserving and promoting her work – the only example of a male artist doing this for his artist wife in a book that records many women acting in such a diligent fashion for their late husbands. Jacob Lawrence and Gwendolyn Knight lived and painted side by side for more than six decades, never allowing Knight's arduously long period of being overlooked to dampen their enthusiasm for each other or their work.

Other artist couples were less at ease with one another and at times found that their greatest artistic rival was their lover. Jasper Johns and Robert Rauschenberg's relationship did not withstand the sudden fame and accolades that Johns received, thanks to his lover's connections. Raoul Hausmann and Hannah Höch discovered and developed photomontage side by side, but after terminating their tumultuous relationship Hausmann barely mentioned his former mistress's presence. Also written out of the picture was Lee Miller, barely mentioned in Man Ray's autobiography. Their fascinating relationship began as teacher/apprentice, morphed into artist/ muse and eventually became collaborative, until finally it imploded as a result of jealousy and competitiveness.

This leads us to the many stories that examine artist collaborations. We tend to think of artists as solitary figures, alone with their genius and torment. From the modern period, an increasing number of artists collaborated on works together, each bringing a special quality to the duo and managing to keep the

peace in order to be productive. This is particularly fascinating when we think of a romantically involved couple making art together. Could the changeability of passion threaten the art, as was nearly the case with Noble and Webster? Or could the artwork they make consume their entire lives, leaving no ordinary 'Mr and Mrs' beneath the contents of the studio, as was the case with Bernd and Hilla Becher. With Gilbert & George, it is almost impossible to see where the art ends and the people begin. Christo and Jeanne-Claude retroactively named all their work under their joint moniker after three decades. They were so fearful of sidestepping accepted conventions of the solitary artistic genius that it was only after they found success that they felt happy to address the massive omission of Jeanne-Claude's contribution. Another couple who expressed reservations about being known as collaborators are Ilya and Emilia Kabakov, who are careful to pinpoint the exact date when the audience could receive their work as a joint effort.

The cautious attitude towards collaboration expressed by two artists who are sharing a life together reveals a deep-rooted concern of all artists: one of originality. The fastest way to deflate an artist's ego is to name all the artists their work reminds you of. Although every great artist steals, said Picasso, it should not mimic or tirelessly repeat what has come before with nothing new to say. Artists can be fearful of other artist's work having a negative impact on the uniqueness of their own. We have already touched upon the ugliness of artistic rivalry in relationships between artists, but there are stories in *The Art of Love* that focus on the healthier and more unknowing side of artist couples, the unconscious influence over time. Just as my husband has made me more patient and modest without me realising it these past 11 years, so too have married artists had an osmosis-like effect on the other's work. For Laurie Simmons and Carroll Dunham, it was unconscious and hindsight has allowed them to see tiny threads linking their two very diverse, robustly independent practices. The same is true for Annie Morris and Idris Khan, who, as well as being the other's greatest champion and expert, are also realising the subtle acts of change they have brought to their spouse's very different artistic landscape.

In the months it has taken me to write this presentation of 34 artist couples from 1880 to the present day, I have come across more romantically engaged artists than I could have imagined. Plenty of artists and colleagues offered new suggestions of brilliant couples to research or meet. It is not so strange in some respects that a person of an artistic temperament should fall in love with a fellow creative. As Morris and Khan see it: it is the best way to

live they can imagine. There were many artist couples that were considered and whose stories remain unwritten here, including Wassily Kandinsky and Gabriele Münter, Natalia Goncharova and Mikhail Larionov, Michael Landy and Gillian Wearing, Rob and Nick Carter, Mat Collishaw and Polly Morgan, Robert Motherwell and Helen Frankenthaler, Tom Doyle and Eva Hesse, Claes Oldenburg and Coosje van Bruggen, Bruce Nauman and Susan Rothenberg, David McDermott and Peter McGough, Michael Elmgreen and Ingar Dragset, Antony Gormley and Vicken Parsons, Alex Hartley and Tania Kovats, Tai-Shan Schierenberg and Lynn Dennison, and Ben Langlands and Nikki Bell.

In my selection, I endeavoured to give the broadest possible artistic spectrum of the past century or so and as many different perspectives on artists in love as possible. The artists here represent 13 nationalities: American, Brazilian, British, Canadian, Cuban, Czech, Danish, Dutch, French, German, Japanese, Spanish and Swiss. Had Bharti Kher and Subodh Gupta wanted to be included, we would also have Indian on that list. But alas, they loved the idea of the book but not the loss of their privacy. As two giants of contemporary art, they have managed to chart their careers without revealing anything of their marriage, and it is understandable in that case that they should want to protect it.

The Art of Love is art historical in nature, with only 17 artists out of 68 alive today. It reflects those artists who reached prominence and were accepted in the twentieth century. It is therefore the stories of mainly straight, white couples, with only Lili Elbe and Gerda Wegener, Gilbert & George, Florence Wyle and Frances Loring, Ethel Mars and Maud Hunt Squire and Robert Rauschenberg and Jasper Johns opening up the conversation about non-binary gender and queer artist couples.

Finally, I circle back to the prickly thorn of biography; this book would be impossible without it. I wholeheartedly believe that art should be able to stand alone from its maker, their stories, their messy love affairs, their private mistakes and heartache. But I also think art should be opened up, made alive and allowed to shine to the greatest number of people. It is my hope that through the spell of romance and artists in love, new audiences will come to the art beautifully represented in these pages by Asli Yazan. They are all by now my old friends and I hope this book enables you to cherish their tales and art as much as I do.

Kate Bryan, 2019

Françoise Gilot

&

Pablo Picasso

1943–1953

Pablo Picasso dominated twentieth-century art in a career spanning nearly eight decades. He is one of the world's most prolific artists, creating as many as 50,000 artworks in his 91 years. More than that of any other artist, Picasso's extraordinary output was tied to his biography: his art can be read as a diary of his life and loves. It does not always make for easy viewing, because although Picasso was a singular modern genius, who could be generous and affectionate, he was also a volatile and difficult man. He left behind him a trail of devastation as he moved on to new sources of excitement, quickly tiring of wives and lovers and overlooking his children and grandchildren.

Picasso's first wife, Olga Khokhlova, was haunted after he left her; she wrote to him daily and followed him around the South of France to berate the artist and his new lovers. On her deathbed, she begged him to visit, but to no avail. Picasso's young mistress, Marie-Thérèse Walter, spent the last decades of her life in mental health facilities, eventually committing suicide on the 50th anniversary of meeting the man who had dominated her life. The woman he left her for, Dora Maar, had a nervous breakdown after her split with the artist and underwent electroshock therapy, finally retreating to a nun-like existence: '*After Picasso, only God.*' In 1973, Picasso's last wife, Jacqueline, banned most family members from attending the artist's funeral; days later, his grandson Pablito committed suicide by drinking a bottle of bleach. Thirteen years on, after doggedly executing his will and tortured by his absence, Jacqueline also committed suicide.

Of all the important women in Picasso's life, only Françoise Gilot has survived with her heart and mind intact to tell the tale. She was the only woman to abandon Picasso, something he would never forgive her for. Like two of Picasso's other great loves before her, Fernande Olivier and Dora Maar, she was also an artist, and like them she will primarily be known as Picasso's lover, despite her many accomplishments. What set Gilot apart from the rest was her fierce intellect and her canny ability to play Picasso at his own game as he tried to capture, undermine and test her affections.

They met in Paris in May 1943 when Gilot was 21 years old and Picasso 61. He left his table at Le Catalan, an artist's restaurant where his lover Dora Maar sat with friends, to join Gilot and her friend Genevieve. He bought them a bowl of cherries and when they told him they were both artists he burst into laughter: '*Girls who look like that can't be painters.*' Despite what Picasso thought, Gilot was indeed a painter and already selling her work. Like everybody else in German-occupied Paris, she knew who Picasso was; he had by then been established for over four decades. Along with her friend, she accepted an invitation to visit him at his studio; both young artists were desperate to see his paintings. It was impossible to see Picasso's work on display in museums and galleries, as he had been labelled a degenerate artist by the Nazis, so a visit to his studio was a deliriously exciting opportunity for education.

Gilot began to make more visits alone, and before long it became clear that Picasso was infatuated with this headstrong young artist. After six months of intellectual engagement, talking about his paintings, stealing moments alone (there was always a court present in the many rooms of the famous studio), Gilot finally conceded her heart to Picasso: '*I had not thought before then that I would ever love him. Now I knew it could be no other way. He was obviously capable of side-stepping all stereotyped formulas in his human relations just as completely as in his art.*' He was technically still in a relationship with his mistress Maar, married to Khokhlova who refused him a divorce and had two children. Gilot knew what she was getting herself into: she was not infatuated with his fame and was not enamoured by his short stature; this was not puppy love. '*I knew that whatever came to pass – however wonderful or painful, or both mixed together – it would be tremendously important.*'

Gilot and Picasso spent ten years together between 1943 and 1953 and had two children, Claude and Paloma. For Picasso, Gilot represented a safe, idealised retreat from reality; with her, he could be pure brilliant sunshine and with others moody and belligerent. Picasso was a

temperamental genius; he gorged on his own intellect and simultaneously delighted and loathed the unfaltering respect he received from all corners. His world was sycophantic: he dangled paintings before the eyes of hungry dealers, playing them off against one another just as he tormented his mistresses, once cruelly delighting in seeing a heartbroken Marie-Thérèse Walter and Dora Maar in a physical fight. He often tested the limits of Gilot's affection for him, and when she refused to take the bait, he would scream that she was cold, calculating and unkind. His biggest disappointment was that he could not fully command, contain or understand her.

Unlike mistresses before her, Gilot did not energise him as a sensual object, but as an intellectual partner. They would stay up late talking about painting and philosophising, and Picasso would share dazzling insights into his unique world view and artistic mind. Gilot managed to carry on painting, despite the chaotic nature of their household and the demands of two young children and an ever more dependent partner.

Picasso introduced his lover to his dealer Daniel-Henry Kahnweiler, who was successful at selling her paintings, mostly to US collectors. He also introduced Gilot to one of her artistic heroes, and his own friend and rival, Henri Matisse. Upon hearing how Matisse proposed to paint her, Picasso territorially made portraits of Gilot. Unlike many others before her, Gilot was thoroughly unimpressed by being a muse and asked him not to use her name for the painting titles. She loved Picasso because she was a painter not because she was a narcissist.

For the last two years of their relationship, Gilot was exhausted and unhappy. Picasso, ever the sadist, was badly behaved and unsympathetic to her ill health, caused in large part by being denied rest in a disruptive household. Eventually, she made the decision to leave, despite Picasso threatening: *'You're headed straight for the desert.'* In the same way that she entered the relationship with her eyes wide open, she left it, knowing Paris would be a poisoned chalice for

her. She relocated to New York where she lives to this day, still painting at the age of 97 having outlived the great force in her life. As well as a lifetime of painting, Gilot also created a beautiful and compelling memoir chronicling her decade with Picasso. He tried to ban its publication in 1964 but failed. He would always take on Gilot and never understood why he could not win. He was a man that famously thought women were either *'goddesses or doormats',* but what he failed to grasp, with all his macho ego, was Gilot's fundamental position. *'It's a bad idea that women have to concede. Why should they? That was not for me. Probably I was a bit ahead of my generation.'* Gilot spoke to Picasso only once after she left him, on the telephone after her book was published. Her accomplishments post Paris are many, and she has been fiercely vocal about them so as not to be seen in his shadow. However, there is no escaping that one of her life's great victories was to be the only lover to outmanoeuvre Picasso.

Pablo Picasso

Frida Kahlo

&

Diego Rivera

1927–1954

Frida Kahlo is the most famous woman artist in history. Today, she occupies a cult status: her image emblazoned on T-shirts and her life the subject of scores of books and even a Hollywood film. Like Che Guevara, she has become an instantly recognisable, international touchstone capturing something heroic, spirited, 'other' and powerful in its distinctiveness. It is quite possible that most who recognise her know very little about her life and art, such is the unconscious prevalence of Kahlo's iconography. However, even those only fleetingly familiar with her will know that the central force of her life story was her relationship with fellow Mexican artist Diego Rivera, which has become mythologised beyond recognition.

Physically, the pair made an almost farcical couple: the beauty and the beast of the art world, or as her parents described them *'the elephant and the dove'*. Kahlo was uniquely attractive and she cultivated a compelling public image in both her plentiful painted self-portraits and in real life, as conveyed through photographs in publications as esteemed as *Vanity Fair* and *Vogue*. She emphasised certain facial features, famously exaggerating her eyebrows into a rhythmic monobrow and upper lip hair into an unabashed moustache. She also commanded a unique dress sense, wearing brightly coloured traditional Tehuana costume and decorating her hair in elaborate folk styles. She was 21 years younger, 12 inches shorter and 200 pounds lighter than Rivera, who wore ill-fitting suits and saw the world through his big ego and bulging eyes.

Kahlo was not shy about their contrasting appearance. In love letters to Rivera, she often described what would have been considered by others as bodily shortcomings – his big white stomach and pendulous breasts – as sensual sites of affection. She was also not threatened by the fact that their art and status within the art world were at opposite ends of the spectrum. Rivera was a famous muralist, adopting the Italian fresco tradition in service of the Mexican revolution. His work was literal, vast, public and political. Kahlo, by contrast, was a more intimate artist in every respect: her painting was unrecognised for much of her life and her subjects were always personal, with a surreal, mythical quality. Rivera's career centred on the ambitions of a newly reborn Mexico, retelling the story of his homeland through the prism of revolution. Kahlo's art was a site to express a lifetime of pain, a form of highly complex catharsis that borrowed from traditional Catholic imagery and salacious news clippings.

So central is the narrative of suffering in Kahlo's work that in Mexico she is known as *la heroína del dolor*, or 'the heroine of pain'. She contracted polio at the age of six and spent a large part of her childhood alone in bed convalescing. Aged 18, she was involved in a brutal traffic accident when the bus she was riding was hit by a tram. Kahlo's already shrivelled polio leg was fractured in 11 places; she also broke her pelvis, collarbone, spinal column and two ribs and her right foot was crushed. One of the passengers was carrying a parcel of gold dust, and in the aftermath of the impact, Kahlo was discovered with her clothes ripped off and her naked body covered in sparkling gold. This would quickly become part of her self-cultivated

narrative, the broken angel who would drolly state: *'There were two great accidents of my life, one was the tram and the other was Diego.'*

It was Kahlo that instigated their relationship when she turned up as he painted a mural at the Ministry of Education. Having taken up painting from her bed, as she waited for her body to heal, Kahlo forcefully demanded a critique to know if, in the eyes of the greatest living Mexican artist, she should continue. The validation and support Rivera gave her painting that day remained constant. They began courting soon after meeting, and Rivera knew that *'Frida had already become the most important fact in my life. And she would continue to be, up to the moment she died, twenty-seven years later.'* They married in August 1929, and their wedding photograph was published in the press, with Kahlo's unusual dress – in an age dominated by imported flapper styles – described as *'peasant's garb'*.

Although their respect for each other as artists never waned, their marriage was tumultuous and riddled with infidelity. Rivera prided himself on his libido, flagrantly comparing the frequency with which he made love to urinating. His affairs were compulsive and reckless: before marrying Kahlo

he had been married twice before and had three children. It is also believed that he abandoned another woman who bore his child. Kahlo often presented an emotionally bruised version of herself in her self-portraits, which make up more than a quarter of her 200 paintings. She poured her bloody devastation after a brutal miscarriage into *Henry Ford Hospital* in 1932, and in *A Few Small Nips* (1935) she removed herself from the scene that recorded Rivera's most sadistic betrayal: conducting an affair with Kahlo's sister Kristina. Taken from newspaper clippings that recounted a callous murderer reporting to a judge that the multiple stab wounds he had inflicted upon his wife *'were just a few nips'*, Kahlo presents Rivera as the criminal and her sister as the victim in a tableau scene that borrows from Catholic ex-voto paintings. Rather than a scene of holy martyrdom that one might find in a church, it is a harrowing commentary on both the woeful social status of women, as Kahlo saw it, and her husband's cruellest infidelity, which led to their divorce in 1939.

It is too easy to see *la heroína del dolor* as a victim. Kahlo might be most famous for her monobrow and upper lip hair, but her memorable character

Frida Kahlo

is a ferocious mix of potent inner strength, a capacity for self-torture and a flawed psyche that confused pain with winning love. Ever since she was a child, her experience of love was difficult, skewering her young identity. Her mother's only son died as an infant just as she became pregnant with Kahlo. She became her father's favourite of six daughters and cultivated a boyish persona. She wore men's suits, combed her eyebrows and moustache, and as a child understood that her illnesses won her affection that was not otherwise forthcoming. When she convalesced in hospital, bed ridden for the second time in her young life, her mother visited only three times in three months. Kahlo learnt to become staggeringly independent, painting through pain and commanding every room. Rather than a heartbroken bystander to her husband's affairs, Kahlo was also consistently unfaithful with both men and women. Her most famous female conquest may be the US painter Georgia O'Keeffe according to her last journals, and her best-known male lover was Leon Trotsky, whom she and Diego, as communists, invited to live with them rent free for two years after he was exiled from Russia.

By anyone's standards, Kahlo lived an extraordinary life of highs and lows. She met and entranced André Breton, Pablo Picasso and Wassily Kandinsky, but was in almost constant pain from her 30s onwards, seeking new medical treatments and undergoing more than 30 operations, including a viciously painful spine realignment and a partial leg amputation a year before her death. What marks her out is how she embraced life's bitter twists, remarrying Rivera soon after they divorced and continuing to mother the wayward beast, even running him baths with rubber ducks. Despite everything, being together was better than being apart, although Kahlo insisted there would be no sex and no money when they remarried. She wanted to remain independent and conceded: *'Diego is not anybody's husband and never will be, but he is a great comrade.'* Indeed, she was larger than life and famous in her lifetime as a personality and eventually as an artist. Kahlo had two solo shows of her work before her death and was the first woman artist to be acquired by the Louvre. She did not want to miss the spectacle of her success, and in her last months – bedridden with a broken body and an addiction to painkillers and alcohol – she attended the first public exhibition of her work in Mexico on a stretcher.

Kahlo wore and painted her pain; she danced with death, probably killing herself in July 1954 after several attempts to end her long physical misery, a fact Rivera was likely able to conceal by obtaining a death certificate from a doctor friend without an autopsy. In her death, her cult has grown to astronomical proportions, far outshining her famous husband. His work was public and political, no longer relevant or compelling for an audience seeking out intersections between race and gender and revering the highly personal and expressive. Kahlo demands we look at her severe beauty in her self-portraits, and she controls and manipulates her suffering in her own complex narrative. Breton described her beautiful paintings as *'a ribbon wrapped around a bomb'*, a description that also neatly applies to her catastrophic ill health, fierce personality and enduring love for Rivera.

Carl Andre

&

Ana Mendieta

1979–1985

Carl Andre and Ana Mendieta are an exemplary case of the old dictum that opposites attract. Mendieta was fiery, passionate and socially magnetic, and made experimental art with her body and the earth with no clear beginning and end. Everything about her was spirited and intuitive as she created emotive visceral art. Her husband, Andre, could not have been more different. A methodical cerebral character, he was firmly rooted in routine, and his art is pure minimalism: rational, careful, quiet and emotionally detached.

However, it is not the extremity of artistic difference that sustains interest in this marriage but the infamy of its end in 1985. Even today, members of the international feminist movement WHEREISANAMENDIETA stage protests at public institutions, such as at Tate Modern in London in 2016. They ask questions because Andre's work is being exhibited and Mendieta's is not. However, this is not a simple case of demanding equal representation for women in the art world, as much as this remains a vital issue today. Their protest is angrier and more personal, because many are survivors of physical abuse and are demanding to know why Andre, whom they perceive to be a violent man, is still honoured by the art world. To them, and the women that protested the same issue three decades before, the narrative of Mendieta and Andre should not focus on their personal and artistic differences but rather tell a story more complex and disturbing: that of the alleged murder of Mendieta by Andre.

On 8 September 1985, Mendieta was found dead wearing nothing but blue underwear, having fallen 34 storeys from the couple's bedroom window in their Manhattan apartment. Andre told police that *she had somehow gone out the window*. The couple had been drinking heavily and arguing, a common occurrence, and on this night, the domestic ugliness ended in tragedy. Andre, found by emergency services with scratch marks, said he did not remember the events leading up to his wife's death. He was charged with murder but firmly maintained his innocence, even as Mendieta's friends insisted suicide was impossible. She was afraid of heights and her career was thriving; she was apparently happy and confident in the recent upsurge of interest in her work. Andre was acquitted of all charges three years later, and today remains a significant US artist. At the time, those taking sides against Andre were quick to point out that his career was simultaneously taking something of a nosedive in critical and public recognition as his wife became more successful.

Andre's work rose to prominence in the mid-1960s. He is considered a key exponent of minimalism, dramatically altering perceptions of what sculpture could be and how it might be presented. Alongside Donald Judd, Eva Hesse, Sol LeWitt and Dan Flavin, he was a vital voice within a new group

Ana Mendieta repeatedly created silhouettes or imprints of her body in mud, rocks, leaves and flowers.

of artists, who rejected the expressionistic creativity of the previous generation and instead favoured cool, detached presentations of often industrial and geometric-looking forms. Andre is especially lauded for rethinking the making and presentation of sculpture. He did not carve or model anything; rather, he took pre-existing blocks and sorted or placed them. One of his most famous and controversial works is *Equivalent VIII* (1966), an arrangement of 120 bricks installed directly on the floor in a rectangular block consisting of two rows. In contrast to the concurrent trend for conceptual art, Andre's sculptures very much point to their own materiality: the blocks are all 'equivalents' of one another and for him the value of the piece centres on its essential properties. It is not an idea; it is very much an object, and the ease with which it is apparently assembled – its pure minimalism – is for Andre the access point to think about matter and substance.

Mendieta's work was never so detached and formal. Born in Cuba in 1948, she became a child refugee of Fidel Castro's regime and was brought up in the United States. The restlessness of her spirit stemmed from this separation from her family and homeland and is a reoccurring theme of her evocative and personal creative endeavours. Mendieta invoked Cuban folk traditions in her practice, which was deeply rooted in her own body and its connection and placement to the earth. She repeatedly created silhouettes or imprints of her body in mud, rocks and leaves, as well as an ongoing interrogation of her female and Cuban identity in her self-portraits, memorably depicting herself covered in blood or disguised as a man with facial hair adhered to her young face. There is an anxious energy in her work, for she may have shown the imprint of her body in flowers but in the next work that same silhouette could be set ablaze in a violent disembodiment of her identity.

By the end of the 1970s, the feminist art movement had begun to make inroads into the conservative and male-dominated art world of New York. Mendieta was working at a time when female identity, visceral projections and investigations into a woman's value in the arts and the reclaiming of the female form by women in art history were starting to make an impact and to set a new standard for future generations of marginalised artists. Andre, on the other hand, was no longer considered a radical minimalist force: as with every new movement in art, the next generation is antagonistic to what came before. Andre's work had just been on a museum tour, but critical reception was mild and attendance somewhat disappointing. It is against this backdrop of their supposed artistic rivalry that the mythology of Mendieta's death is staged.

There is, naturally, a resistance to the tokenistic artistic canonisation of a young woman, stopped in her tracks just as her career gained critical recognition. It is only in recent years that a well-considered and thorough examination of her entire practice has been presented in museums. These exhibitions have demonstrated with authority that Mendieta was a progressive and creatively brilliant artist who left behind a legacy that should not be overshadowed by the circumstances of her death, but instead celebrated for its pioneering contribution to feminist art history and praised for its complexity, vitality and originality.

Carl Andre

Ana Mendieta

Christo

&

Jeanne-Claude

1958–2009

From 28 October 1969, for a period of ten weeks, the world's largest artwork existed a short distance from Sydney. Larger than Mount Rushmore, *Wrapped Coast* covered 1.5 miles (2.4 km) of rocky coastline with 1 million square feet (93,000 sq m) of synthetic fabric held in place by 35 miles (56 km) of rope and 25,000 fasteners. The staggering creation took 17,000 man hours and more than 100 people to complete, over the course of four precisely planned weeks. The vast intervention into the landscape stayed true to the natural form of the cliffs, and despite wrapping them did not conceal their natural splendour. In fact, the fabric emphasised the wonder of this section of the Australian coast. The artwork was temporary but its existence is lodged in the imaginations of millions and is synonymous with the stupendously ambitious husband and wife duo known as Christo and Jeanne-Claude.

The artists have produced some of the most awe-inspiring, absurdly impressive, memorable and influential artworks of the past 50 years. They have achieved this entirely on their own terms, without a single dollar of arts funding, sponsorship or commercial gallery assistance, even though their projects run into the millions to produce. They are universally respected in the art world, with their preparatory work collected in major museums globally, and yet they make absolutely no profit from their large-scale temporary endeavours. One of the most charming, though probably at times infuriating, qualities of the couple is that they are partially blind to how unconventional they are. Even something as simple as their names is confusing at first. They set the record straight on their website, which has an unintentionally amusing page called 'Most Common Errors'. The first of many is: *'Christo is his first name and the only one he uses. Jeanne-Claude also uses her first name. However, their son Cyril uses Christo's first name as his legal last name: Cyril Christo, born May 11, 1960.'*

Free of surnames, the couple began working together in 1961. However, their practice was known only by Christo's name until 1994, when they retroactively re-authored all artworks made in collaboration as being by Christo and Jeanne-Claude. Their tactic initially was that it was

Christo and Jeanne-Claude's work often involved wrapping vast areas, including the rocky coastline near Sydney, Australia.

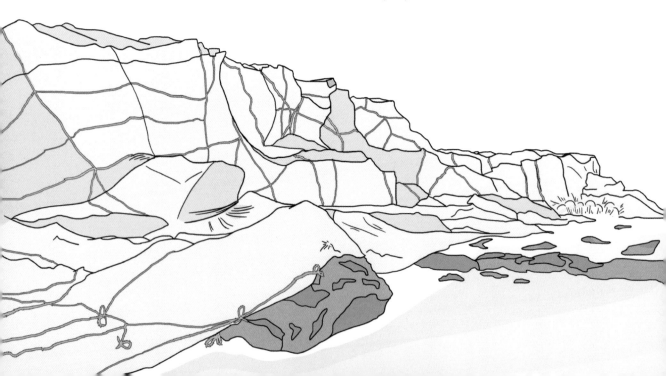

simpler to have one artist's name attached to their work, but once their collaborations became internationally famous and it was clear that this was very much the work of a unit of two, it was important to re-address an outdated decision from the 1960s. Jeanne-Claude died in 2009 at the age of 74 and Christo survives her, still making work under their joint banner, as for the most part their projects take decades to realise and were thought up while his wife was still alive.

In addition to the peculiarities of their name and the authorship of their artwork, there is the tricky subject of their medium. Having wrapped a coastline, monuments, museums and even the Reichstag in Berlin, the pair are often described as the 'wrapping' artists, but not all their work involves this technique. Among their 22 realised projects, they have also created a 1.6-mile (2.5-km) floating pier on an Italian lake, a 21-mile (34-km) fence in California and a 7-mile (11-km) curtain between two mountains in Colorado. Because of the temporary nature of their work, and the bureaucratic nightmares that must be overcome to realise them, they are considered by some to be conceptual artists, and by others land artists. They reject both of these labels as 'idiotic' and describe themselves as environmental artists with a common denominator of fabric, cloth and impermanence. More important than how they make their work, and how it might be categorised is their objective. They have always seen themselves as adding something to humankind's history of creative endeavours by isolating *the quality of love and tenderness that human beings have for what does not last . . . For instance, if someone were to say, "Oh, look on the right, there is a rainbow," one would never answer, "I will look at it tomorrow."*

When Christo met Jeanne-Claude in Paris in 1958, he was already parcelling up objects, inspired by Marcel Duchamp and Man Ray. Having fled communist Bulgaria, he had recently arrived in the city and was working as a traditional portrait painter to support his more avant-garde practice. The work created in the privacy of his attic studio was signed Christo, and the public

portraits by his surname, Javacheff. Jeanne-Claude's bourgeois mother was one of Javacheff's patrons and it was at a sitting at her home that Christo and Jeanne-Claude met. The attraction was instant, and Jeanne-Claude promptly left her husband of three weeks and ran away with Christo. Her family did not speak to her again for over two years. Within a year, she had given birth to a son and had commenced her role as the determined, fierce but charismatic, stage manager of her husband's work.

In 1964, they emigrated to New York, where the scale and ambition of their ideas seemed limitless. With an indefatigable energy and diplomacy, Jeanne-Claude commanded endless bureaucratic appeals and court hearings to get permits to create their work. Wrapping the Reichstag was an endeavour that took 24 years to come to fruition, involving heated parliamentary debates, countless media reports and unrelenting fund-raising, as well as enduring death threats from neo-fascists and ex-communists. The poignant artwork that bundled up a site of political and social wounds may have only lasted two weeks but it was seen by a record 5 million visitors.

The artists did everything together, sharing a home and studio and working unrelentingly for 12 to 14 hours every day, without holidays, for more than five decades. The only thing they did not do artistically as a pair was drawing. Christo is the hand of the partnership, producing beautiful preliminary sketches of their master plans to sell to fund their gigantic interventions into the landscape. The other activity in which the artists separated was taking planes: they would never fly together out of fear of a plane crash, so that one might carry on working without the other. In compliance with their pact, after Jeanne-Claude died of a brain aneurysm, Christo forged ahead alone to realise their projects. For nearly ten years, Christo, now 83, has lived without his flame-haired beautifully furious diplomat and his best critic. One day Christo too will pass, but much like the temporal nature of their astounding creations, the magic of Christo and Jeanne-Claude will remain a timeless feature of art history.

Robert Delaunay

&

Sonia Delaunay

1909–1941

Paris was the centre of the world at the turn of the last century. Its grand boulevards, elegant new buildings, dance halls, parks and restaurants, all lit with electric lights, were a tantalising glimpse into a new modern era. The large illuminated city with a pulsating culture was the apotheosis of the industrial revolution, which had delivered a new class of people who worked with time free to enjoy themselves. It was an era of profound optimism and social change. Paris was a magnet for bohemians: they were drawn in from all corners and were at the forefront of this brave new world. Robert and Sonia Delaunay did not just capture this spirit in their art, they lived and breathed its ethos their entire lives. Despite the interruption of wars, economic hardship and ill health, they were bright, compulsive creatives, who carried the pioneering optimistic attitude of the early twentieth century with them.

Both artists arrived in Paris with an appetite for its vibrancy, enticed by the space it offered to outsiders, pioneers and the displaced. As children, both Robert and Sonia had been separated from their parents and moved away from home. Robert was born in Paris in 1885 to a countess, and when she divorced his father he was sent to live near Bourges with his aunt. Sonia was born to a Russian Jewish peasant family in Ukraine in 1885, and when she was around six years old she was adopted by her uncle, who gave her a cultured childhood in the refined society of St Petersburg. She left for art school in Germany at the age of 18, able to read and write four languages and determined that she would not go home to Ukraine.

By the time Robert and Sonia met in Paris, Sonia was already married to Wilhelm Uhde and showing her paintings in the same exhibitions as established giants of the Parisian avant-garde: Pablo Picasso, Georges Braque and André Derain. She was 22 years old and her husband was her confidante and social partner but not her lover. An art dealer, Uhde was gay and the marriage was one of convenience. Sonia was a confident, progressive young woman who arrived in Paris alone in 1905 determined to paint and be part of the capital's avant-garde art scene. She was, however, ahead of her time: her wealthy uncle refused her an income until she married and found her unsettled life very unbecoming, demanding she return to St Petersburg unless she found a husband. To give both her and Uhde social security, they wed in 1908 and became well-established figures on the art scene. Their parties were attended by Picasso, Braque, Jean-Jacques Rousseau and, fortuitously, Countess Delaunay. Robert attended a soirée with his mother and met his host, Sonia, with whom he fell in love. They were each deeply drawn to the other's philosophical attitude to the art of their time and its dazzling potential. By the time they married in 1910, Sonia was already pregnant with their son.

It was in the months after his marriage to Sonia that Robert made a leap from the neo-impressionist paintings he had been making for several years to something original, which elevated his position within the art world and secured him a legacy in art history. Robert's new style was borrowed from cubism, but he took the pioneering broken surface developed by Picasso and Braque further into abstraction. Rather than the muted brown palette of cubism and its intellectual, inward-looking approach, Robert conjured fantastic interplays of colour and light. He did not entirely abandon form and subject, capturing the Eiffel Tower and the windows of Paris in his lively, dynamic compositions.

It is not surprising the artists each developed so quickly after coming into each other's orbit. Sonia and Robert were fantastic artistic sparring partners for one another: their friend, the poet and art critic Guillaume Apollinaire, observed: *'As they wake up, the Delaunays speak painting'* as if it were a language of their own. Sonia did not allow the task of motherhood to dampen her creative endeavours; rather, it seems as if her young son fuelled her output. Now recognised as a key work of 1911, a quilt made for her baby has become a pivotal masterpiece for Sonia. This riot of colour and shape still looks distinctly modern and paved the way for an experimental body of work that Sonia made away from the canvas, painting walls and making cushions, lamps and clothes. Sonia was a pioneer who endeavoured to abolish hierarchy between art forms, asserting: *'For me, there was no gap between my painting and what is called my "decorative" work.'*

The modernist belief in equality between art forms did not materialise, and historically much of Sonia's output was overlooked because it did not belong to the realm of fine art. For many years, she was considered an inferior artist to her husband. There is even an argument to suggest that Sonia stopped painting after she married Robert, as she was respectful of his fragile ego and wanted to step aside, choosing a feminine sphere of work. This view fails to consider the strong partnership the Delaunays enjoyed: they were intensely committed to their marriage and between them developed a form of art they called *simultanéisme* (simultaneity). The word, which they patented, was the centre of their creative system and referred to the movement, rhythm and energy created by placing contrasting colours alongside each other. Robert found *simultanéisme* on canvas, and Sonia too made several key paintings in this new terrain. More striking, though, is the way she lifted their invention from the world of fine art and let it live and breathe as a form of life.

This is perhaps best exemplified by the image of Sonia in a proto-performance piece, wearing one of her own dynamic colourful designs, twirling and unleashing *simultanéisme* on the dance floor at Bal Bullier in Paris. Robert called her a *'living sculpture'*, as if the whole world were her stage. Dressing them both in zigzags, stripes and bright

The image of Sonia Delaunay in a proto-performance piece best exemplifies the form of art the Delaunays called simultanéisme.

colours, Sonia launched the Delaunay brand: they did not just talk and paint *simultanéisme*; they were its living embodiment. Later, she would open her own boutique producing one-off items of clothing, all hand-made and all considered wearable works of art. The couple were at the centre of the avant-garde and their salons became a respected space for experimental art.

The couple were affluent but suffered setbacks in line with the tumultuous period in which they lived. In 1919, the Bolshevik Revolution cut off a vital private income from Russia and later the Wall Street Crash and Second World War interrupted their social security but did not dampen their vivacity. In fact, it was in these moments that the Delaunays showed themselves to be very adaptable. Sonia was a canny entrepreneur and her progressive decorative work became a commercial lifeline for the couple.

After Robert died in 1941, Sonia diligently preserved his life's work and ensured his legacy. This was not at the expense of her own career, which kept thriving. Sonia remained extremely productive and her designs won her popularity in France as a household name. In 1970, French President Georges Pompidou gifted one of her circle paintings to US President Richard Nixon, thus demonstrating that Sonia Delaunay was one of the greatest exponents of French culture. In 1964, she became the first woman to have a solo show at the Louvre and was awarded France's highest accolade, the Légion d'Honneur. Her design work and painting were her life force; she stated simply: *'I have lived my art.'* Robert may have passed 38 years before, but the spirit of *simultanéisme* stayed within her: the bright, joyous way of capturing the world was still at play as she painted on the morning she died, aged 94.

Sonia Delaunay

Lee Krasner

&

Jackson Pollock

1941–1956

Fame is a tricky beast and a great amplifier: it can take what might be the worst characteristic or fact about a person and intensify it. When Jackson Pollock became famous throughout the country as the United States' greatest living painter, a status prompted by *Time* magazine in 1949, it fuelled not only his ego but also his deep insecurities. When Lee Krasner became known for being Pollock's widow, and later one of the twentieth century's most overlooked US painters, it afforded her a platform, but one that exaggerated her life in her husband's shadow. It is unfortunate that neither artist was entirely well served by their fame, but important not to cast either as powerless, as both artists displayed a forceful tendency for making life more difficult for themselves. Between them, we find an intoxicating mix of obstinacy, insecurity, despair and self-destruction.

The well-worn narrative of the couple is that Pollock was the great abstract expressionist talent, whom Krasner supported despite his often appalling behaviour, and that his work deeply influenced his wife's painting. The accepted version of events casts Krasner in a spectacularly secondary role in their marriage and careers. However, when the artists met in New York in the 1940s, it was Krasner who was the more established artist, already exhibiting her work with good connections in the art scene. She was extremely well versed in art in a way that the inarticulate Pollock would never be. She was strong minded and outspoken and had a forceful personality, traits she would need in the macho avant-garde circle she became part of.

Pollock acted tough but he was unsure of himself, always searching for a father figure and approval. Although he felt instinctively that he wanted to be an artist, he struggled because he was not a natural draughtsman and lacked discipline. Unlike Krasner, he was not intellectual and did not have an aptitude for education nor appreciate the finer things in life. By the time he first met Krasner in 1936, he was already an alcoholic and had been drinking since the age of 14. Their first encounter was not the stuff of romance novels. Pollock was very drunk at an Artists Union party and cut in to dance with Krasner, rubbing himself suggestively against her thigh and whispering in her ear. Krasner slapped Pollock, but later softened, and accounts vary as to whether they went home together. Despite his bad and often lewd behaviour, Pollock had a knack of charming people into submission. Moreover, Krasner was no wallflower; she was a tough young woman with no time for weakness.

After that evening, the artists did not see each other again until November 1941, when they were among a handful of US artists selected for an exhibition

alongside modern giants such as Henri Matisse. Although well ensconced in the fledging New York art scene – and the only woman chosen for the show – Krasner did not recognise Pollock's name on the exhibition leaflet and asked around. When she discovered that the artist lived a short distance from her own studio, she paid an unscheduled visit. It was apparently love at first sight: *'I was terribly drawn to Jackson and I fell in love with him – physically, mentally – in every sense of the word. I had a conviction when I met Jackson that he had something important to say.'*

This infatuation arose despite the fact that the artist was not in a good way at the time. His recent spell of extreme drinking and unstable behaviour was of such a concern that he was admitted to a psychiatric hospital. Six months before Krasner knocked on his door, Pollock's doctor assessed him as an *'inarticulate personality of good intelligence, but with a great deal of emotional instability who finds it difficult to form or maintain any kind of relationship'*. Krasner could not have known what she was getting herself into.

In 1945, after the war ended, they married in a mood of ebullience and moved to a rural area of Long Island where they both painted for 11 years. Although she was his complete support system, Krasner kept her distance from Pollock's artwork when she was painting: *'We shared the bedroom, but not the studio, and we maintained a strict by-invitation-only discipline about going into each other's studios.'* At first, the move from the city was a tonic, and 1946 was the happiest year of Pollock's life. Later, he managed to stop drinking for three years. In 1947, Pollock reinvented paint on canvas with his 'action paintings', created by pouring and dripping household paint directly onto canvases laid flat on the floor. He was suddenly a phenomenon of the kind he and his New York circle had never witnessed.

By 1951, at the height of Pollock's career, his life had spiralled out of control. His fame was too big and too fast, and along with the adulation came criticism. Pollock was a wreck: outwardly aggressive and simultaneously very thin skinned. In the summer of 1956, he began a relationship with Ruth Kligman, a young art student. Pollock did not try to hide his mistress; instead, he paraded her socially. Krasner was under no illusion that Pollock was a faithful, model husband, but this open goading was a step too far and she left for Europe, refusing to be witness to her own humiliation. Pollock was out to annihilate himself: his behaviour isolated even his greatest supporters and he was creatively stagnant, having not completed a painting for over a year. On the evening of 11 August, less than a mile from his home, a very drunk Pollock lost control of his car, which contained Kligman and her friend Edith Metzger. Only Kligman survived.

The artist's death sealed his reputation as a tragic genius, hell bent on destroying himself. A few years later, Krasner found herself amid a commercial frenzy: as Pollock's legend grew so too did the value of his artworks. Krasner resisted the urge to make a quick profit, and instead she cautiously and judiciously administered his estate. She was responsible for many of his works entering museum collections and also for archiving his practice. This dedication to what she knew to be great work came at a cost

to her own career: had she not been so closely involved with his posthumous reputation, she would not have been so easy to tag as Pollock's widow.

Krasner received very little attention as an artist after marrying Pollock, but she was not the only one in his shadow. Many of the abstract expressionists felt a strong rivalry with him, Willem de Kooning perhaps more than anyone. Three years after her husband died, Krasner began to paint what are now considered to be some of her finest works; many think of them as a breakthrough. Having witnessed the ascendency and catastrophic unravelling of her husband, she was not inclined to go on a charm offensive in the art world, instead maintaining a cool distance. She continued to work into her 70s despite the ill health that had plagued her since the early 1960s. In 1983, she lived to see a touring museum retrospective of her life's work, having experienced a revival of interest in her career thanks to the women's movement. But even today, critics are guilty of discussing her work in relationship to Pollock's; for better or worse, their lives are inextricably linked and so too is their art. Krasner never played the victim: she loved Pollock and in a world that turned him into an artistic icon, she was far and away his truest and most faithful fan. Shortly before she died, she was asked about the shadow of his legacy: *'I don't feel I sacrificed myself. And if I had to do it all over again from the very beginning, I'd do the same thing.'*

Pollock reinvented paint on canvas with his 'action paintings'.

Jackson Pollock

Barbara Hepworth

&

Ben Nicholson

1931–1951

Barbara Hepworth and Ben Nicholson are the quintessence of British modernism. Both artists fully subscribed to the church of high modernism and dedicated their entire beings to the pursuit of beauty and truth. Art came first, regardless of world war, triplets and personal tragedy. They were drawn to each other largely because of their serious commitment to abstraction. In the early 1930s, Hepworth and Nicholson were at the centre of the promotion of the international language of abstract modernism. This was not just a form of painting and sculpture that offered new possibilities after hundreds of years of representational art. In Europe, after the horrors of the First World War, abstract art became part of an antidote to an old world order and was a symbol of hope and optimism. As nationalism rose in the early 1930s, artists banded together in the aspiration to create what Nicholson described as *'a powerful, unlimited and universal language'*, something that would transcend borders and unite differences.

Hepworth and Nicholson worked like zealous religious converts and offered each other something of a mirror image. They each believed strongly in the essence and uniqueness of things

and rejected anything so needless as external beautification or decoration. They wanted to unlock something eternal, spiritual and lasting. In searching for a kind of inner beauty, they had a feeling for the unspoilt, unconscious values of primitive art or art innocently created by children. They did not so much paint and carve as conjure and imagine. Until they met, they were locked in their own heads with these complex vast ideas, so finding a kindred spirit was a revelation. They were both equally fervent in their attitude towards their work. Hepworth described *'an unreasonable and compelling urgency in me to carve'*, and Nicholson spoke in passionate terms: *'I started producing work with an ecstatic addiction.'*

So strong was the attraction when they met on holiday in Norfolk in late 1931 that each artist could not resist the other, despite both already being settled with a spouse and children. In order to be together, they had to sacrifice the stability

Nicholson repeatedly portrayed Hepworth's profile in a reduced way, whilst Hepworth punctured her sculptures with hollow shapes.

of their first families. On the day Nicholson returned to London, he wrote his first love letter to Hepworth, and she replied admitting she too had fallen in love and had been thinking about him constantly. Hepworth's marriage was not always a happy one, and her husband, John Skeaping, was intimidated by his wife's ambition and single-mindedness. In his autobiography, he revealed a reservoir of difference between himself and his intellectual wife: *'Barbara was very unsexy and I was just the opposite.'* The couple parted in relatively easy terms, but things were not so straightforward for Nicholson, whose wife, Winifred, resisted the divorce for years after Nicholson left her and the children. The pair stayed on cordial terms and, as mother to his children and an artistic peer, Winifred remained in his life.

Despite the wreckage caused by coming together, Hepworth and Nicholson found in each other a determined kindred spirit and further unlocked their burning commitment to their practice. Nicholson moved into Hepworth's studio in Hampstead in March 1932 and they embarked on an art pilgrimage to visit the studios of the European modernist artists they admired, including Pablo Picasso, Constantin Brancusi and Georges Braque. In Hans Arp and Sophie Taeuber-Arp, they found not only inspiration in the field of modernist abstraction but also a fellow artist couple on whom they could model themselves. Hepworth and Nicholson were increasingly philosophically aligned and each other's best critic. Shortly after moving into the Hampstead studio, Nicholson wrote: *'Barbara and I are the same . . . Our ideas and our rhythms, our life is so exactly married that we can live think and work and move and stay still together as if we were one person.'* The art they made before the war was as close to collaborative as two artists can get without physically working together on one piece. The studio

environment was a fertile nucleus of shared ideas: Nicholson's work became more sculptural and he repeatedly portrayed Hepworth's profile in a reduced, nearly abstract way in his linocuts and paintings; Hepworth began to reduce her visual language even further, puncturing her sculptures with hollow shapes. Inspired by Nicholson's painting and colour theory, she also began to paint the inside curves of her sculpture.

The artists were thoughtful about the language they used when speaking about art, and both contributed to important art theory in the 1930s. Nicholson expressed: *'I'm interested in locating the holy grail of the minimum means to express the most complex ideas',* which closely chimed with Hepworth's outlook. As nationalist tendencies displaced people across Europe, Hampstead became a refuge for modern artists, such as Piet Mondrian, Walter Gropius and Naum Gabo. In 1934, the couple collaborated with Gabo on a journal called *Circle*, which Hepworth designed and Nicholson edited. It was a time of great energy in London, Hepworth recalled: *'England seemed alive and rich – the centre of an international movement in architecture and art.'*

For two artists so ardently locked in the philosophy of modernism in the Hampstead conclave, things did not entirely go to plan. The same year that the artists worked with Gabo on *Circle*, Hepworth unexpectedly delivered triplets, which was of no advantage for either seeking intense studio time. After Nicholson finally divorced Winifred, he married Hepworth in November 1938. A year later, the week before the Second World War was declared – a blow to the hopeful spirit of the universal language – the couple reluctantly evacuated London for St Ives in Cornwall, with the children and the cook. Their London milieu dispersed, and all the artists retreated, but ironically St Ives proved to be the most important creative stimulus in the careers of both artists. Here, they felt locked into the landscape, and they allowed their abstract forms to stand for metaphors for human relativity to nature. Hepworth particularly created works with a deep resonance to the wild, ancient terrain.

After the war, Hepworth was part of the dialogue about the healing capacity for abstract art, and alongside Henry Moore she was a significant force in taking art to public places as a kind of British cultural reconstruction. She enjoyed success on an international scale in a man's world and in 1950 exhibited at the British Pavilion at the Venice Biennale. Hepworth carefully managed her own career and how her work was seen, and she enjoyed the fruits of her labour. Her private life, however, was not so happy, and the year after the Biennale, Nicholson left her. It is no coincidence that his departure was timed to chime with the moment Hepworth's fame and success began to eclipse his own. In her pictorial autobiography, she is characteristically emotionally tight lipped, revealing only: *'In 1951, after 20 years of family life, everything fell apart.'* Two years later, Hepworth's son from her first marriage died in a plane crash, and her world seemed to be closing in on her. She wrote to Nicholson regularly, and for several years possibly expected him to return to her, until he married his third wife in 1957. Nicholson enjoyed museum recognition for his work in the 1950s, but his practice did not develop into any deeper engagement with the challenges of modern art.

Far from being a tragic isolated figure, Hepworth maintained a furious energy in her work, and as the women's movement emerged she dismissed any notion of being a 'woman' artist, asserting: *'Art is anonymous, it is not in competition with men.'* Despite ill health and tongue cancer (which she treated with whisky and cigarettes), she continued to make art until her accidental death from smoke inhalation aged 72 in 1975. Unlike Nicholson, her practice became more assertive and powerful after they separated. She wrote to him celebrating her new work: *'You never liked arrogant sculptures or fierce forms, but I do.'* She did not choose to move to St Ives; it was necessitated by war, and she did not choose to be alone; her husband left her. However, these two facts allowed for some of the most enduring, iconic and successful works of modernist sculpture ever created.

Ben Nicholson

Georgia O'Keeffe

&

Alfred Stieglitz

1918–1946

The photographer, writer and gallerist Alfred Stieglitz was so successful in his master plan to make his young wife, Georgia O'Keeffe, the United States' greatest modernist female painter that it is tempting to see her achievement as singularly conjured and perpetuated by him. After all, he provided for O'Keeffe financially, set her up in a studio, regularly exhibited her work, promoted her to an exalted level and gave intellectual readings of her paintings in his Freudian-influenced writing. He interpreted her work as highly sexualised and the product of a particularly powerful female gaze. He also made her his most famous muse, photographing her more than 300 times, including sensual nudes. Looking at this work and his endeavours, one might be forgiven for believing that he shaped and cultivated her talent and personally delivered it to the world. Was she a passenger in her own career furthered only by the besotted attentions of an influential partner?

True, she benefited from his support and without his strong standing in the New York art scene O'Keeffe could never have achieved such levels of attention so early in her career. However, this version of events neglects O'Keeffe's fierce spirit and would have more validity had she been self-effacing, blindly accommodating and compliant. Her long career was sustained and sealed on her own terms. She rejected Stieglitz's psycho-sexual interpretation of her work – *'when people read erotic symbols into my paintings, they're really talking about their own affairs'* – and was not so biddable that she remained in New York while he openly carried on with other women. She left for New Mexico and found her spiritual homeland, where she remade herself as an independent and autonomous artist. Her husband may have used her obsessively as his model, but after he died she maintained a very sure sense of her image, continuing to be photographed into her 90s as a powerful, natural incarnation of the great American West.

Although O'Keeffe put distance between herself and her husband physically, and rejected his intellectualising of her painting, she did share a deep and lasting love with him. They met in 1915, when she was a 27-year-old teacher, unsure of her art and keen for his critical eye. Stieglitz was already a pivotal force in photography, championing the medium as a fine art form and making lasting contributions in the early stirrings of the US art world as a writer and pioneering gallerist. Aged 51, he was nearly a quarter of a century older than the young painter and unhappily married to an heiress. His relationship with O'Keeffe developed slowly and at a distance over the course of a two-year correspondence, during which O'Keeffe seemed to breathe life into the self-described worn-out old man, who was *'ready for the scrapheap – old junk. – No energy.'* She, by contrast, was full of vitality, and in her letters enthused about the Texan landscape, her paintings and the possibilities of her art.

Brought to life by his infatuation with his *'great little girl'*, Stieglitz emerged from the doldrums of his 30-year marriage, left his wife, installed O'Keeffe in a New York studio in 1918 at his expense and set about his mission to secure her place as a pioneer of American modernism. There is something paternal about his role, which makes it uncomfortable to read letters in

Alfred Stieglitz

Alfred Stieglitz's cloud photo series, Equivalents, *emphasised abstraction so that the images could correspond with his personal emotions.*

which he commemorates the anniversary of the night they first made love and the end of O'Keeffe's virginity. Although there was certainly something commanding about his persona and unfailing belief in her work, O'Keeffe was in turn a vital source of support for Stieglitz, whose public charisma gave way to insecurities and neuroses privately. Their wedding in 1924 was a cherished memory for both, and despite later periods of unhappiness and physical separation, they never divorced.

O'Keeffe enjoyed success quickly. Stieglitz was a respected curator and included her alongside more established artists in numerous group exhibitions. The pair became a well-known couple, especially once Stieglitz made her the unrelenting focus of his work from 1917 onwards. As a muse, she revitalised his photography: she was the catalyst for a pioneering series of images that isolated her hands, feet and neck almost into abstraction. Sadly, Stieglitz's focus on his wife with the camera was not matched by a

faithfulness sexually. In the late 1920s, when O'Keeffe discovered his affair with a young gallery assistant, she left to spend time away with bohemian friends in New Mexico. She was tired of the city and already restless in the marriage; her husband did not want children and O'Keeffe felt stifled by his social circle and obligations to her parents-in-law. In the distinct terrain of the West, O'Keeffe fully found herself as an artist. It was here that she connected with the natural world, painting endless variations of close-up flowers, nearly abstracted landscapes and animal skulls that took on almost ritualistic and sacred properties. The terrain ran through her brush, and her paintings were the embodiment of a life lived in devotion to the natural world around her. In the same way that her husband traversed her body with his camera repeatedly, she painted the same mountain over and over, poetically revealing: *'God told me if I painted it enough I could have it.'*

She originally stayed for five months and Stieglitz knew on some level that he had lost her to the West; *'I am broken,'* he wrote. However, O'Keeffe travelled back often, usually painting for around six months and then returning to New York to exhibit her work. She eventually bought her own property in New Mexico in 1940 and the area became her main residence for the last 37 years of her life. Stieglitz remained her principal champion and devoted husband, despite living largely apart. They seemed to maintain their love successfully as pen pals. When Stieglitz died in 1946, he was content that his ambitions for O'Keeffe's paintings had been realised. Indeed, the year before, she had been the first woman to be honoured with a full retrospective at the Museum of Modern Art in New York. The night before her husband's funeral, O'Keeffe lovingly lined his coffin with clean white linen by hand, his body laid to rest as if set against the neutral untextured backgrounds of her late paintings. She was still only 59 years old and went on to live alone, now wedded to the land that became known as 'O'Keeffe country', until her death at the age of 98. By the 1960s, O'Keeffe had become one of the United States' most famous and best-loved living artists, her popularity confirmed by her *Life* magazine cover in 1968. She had achieved what no US female artist had done before her, and she had done it largely in absentia from Stieglitz.

Both artists were extremely prolific, famous in their lifetime, left behind a great legacy and died knowing they would continue to be a source of interest. Although in her old age O'Keeffe was reclusive and grew weary of people turning up unannounced to catch sight of the great American painter, she was astute in her decision not to destroy 5,000 letters of correspondence with her husband but rather donate them to the Beinecke Rare Book & Manuscript Library at Yale – but only under orders that they remain sealed until 20 years after her death. She knew that it would be a tantalising proposition for future generations to peer inside their marriage. Perhaps she also believed, on some level, that she would be pleased with this first-hand account of her life being available, so that if popular legend swung away from her dedicated, independent career towards an unflattering version of events, then the record could be set straight: she was not Pygmalion's Galatea.

Lee Miller

&

Man Ray

1929–1932

Lee Miller was devastatingly beautiful, well educated, creatively talented and in command of a strong, independent nature. However, these abundant blessings were also afflictions in her life, which was both richly fascinating and ultimately tragic. Miller was the apprentice, muse, lover and collaborator of surrealist artist Man Ray, transfixing him with her unattainable quality. She refused to marry him, despite his appeals to tame and ultimately fully possess her as the object of his romantic and creative passions. After a fervent and productive few years, she morphed in his mind into a threatening artistic rival. Not the kind of woman to let herself be cast in shadow, Miller left her jealous lover, and the great surrealist was reduced to making artwork of questionable quality in an effort to ease his angry heartache.

Miller's life was extraordinary both before and after her time living with Man Ray in Montparnasse. She was discovered as a model by none other than publishing mogul Condé Nast. A cool blonde with strong features, intense eyes and a flawless air, Miller was the face of the zeitgeist. She had long modelled as a child for her photographer father, but the images of a young Miller posing nude for him are disturbing, particularly considering the sad revelation that she was raped as a girl in 1914.

Miller's abuse was part of a deeply sad tapestry of life, which saw men try to possess and control her, regarding her as an object of beauty, a thing to covet and misuse. Simultaneously though, from the outside at least, she appeared to be the very height of glamour and untainted perfection, appearing on the cover of *Vogue* several times. She was 22, a fashion icon and a famous beauty when she left New York for Paris in 1929. Her two lovers tossed a coin to win the honour of seeing her off. As the boat sailed away, the loser flew a plane close to the sun deck and showered her with roses. She inspired the same kind of extravagant devotion in those who met her in Paris: Jean Cocteau cast her in his films and Pablo Picasso, always one for a striking beauty, painted her portrait at least six times.

However, Miller was not a typical empty vessel, beautiful and malleable to a man's demands. In fact, when she met Man Ray it was at her own calculated undertaking. Determined to learn from him, she hunted him down and waited for him in his favourite bar close to his glamorous Montparnasse studio. She tells the story best: *'I said, "My name is Lee Miller, and I'm your new student." Man said, "I don't have students." He was leaving for Biarritz the next day, and I said, "So am I." I never looked back!'* Miller travelled with Man Ray and upon her return to Paris wrote to her father to let him know she was to be an apprentice photographer. She was an instant and never-ending source of inspiration for Man Ray's work. Both outsiders from New York, they had come to Paris to open themselves up to a wilder way of being and making.

Although she started as Man Ray's muse, Miller quickly developed a practice of her own under the tutelage of the adoring photographer, who bought Miller her first camera. At 17 years her senior, he initially occupied a paternal role, but there was quickly a collaborative nature to their time spent in close quarters making art. Indeed, it was Miller who midway through a careful development in the darkroom felt a mouse on her foot and

rushed to turn on the light, accidentally discovering what would become a trademark technique for Man Ray: solarisation. The interruption of the light created a surreal dark aura around the object. The silvery antique quality to the imperfect print became a key development in the history of photography, creating departures into new techniques that helped establish the mechanical medium as a fine art form. The pace of new inventive work quickened. Miller was no longer the student; she was now a collaborator.

By 1931, tensions had appeared. Miller was enjoying fame and adoration that Man Ray could not tolerate. Ultimately, the surrealists advocated a social liberalism, but in reality only intended many of its privileges to apply to men. Man Ray wrote to Miller, demanding: *'You must arrange to live as my wife, married or not.'* Their exceptional fiery love affair was brought to an abrupt halt by something as meaningless as a discarded photographic print, which Miller appropriated, cropping and representing the image. Threatened by her increasing artistic independence, Man Ray threw Miller out in a jealous frenzy. She coolly took the moral high ground and bought a one-way ticket to New York. Man Ray may have been a successful prominent member of the Parisian avant-garde, but this did not stop him prostrating his torment into public works of grief. A particularly self-indulgent presentation was a self-portrait with pistol, noose and poison.

Miller went on to be one of the most courageous and exceptional war photographers of the century. She was the only woman granted permission to travel throughout Europe as an independent photo journalist. Famously, she broke into Hitler's empty apartment on the day he committed suicide, not only stealing scenes of the domestic home of a tyrant but also posing herself in his bed and bathtub. Her work on beach battlefields and even in the bleakest of places, such as Dachau, is unique in its approach. She refused to operate with a detached distance; her work presented the humanity of unbelievable scenes of horror.

After marrying the British surrealist Roland Penrose and having a child, Miller sealed away her photographs and never spoke of her former life. Sadly, it was not a successful transition from wild independent beauty to stable mother. She was tormented by the evils of war and was an unhappy alcoholic. It was only after her death that her astonishing archive was discovered by her son, who had never known of her extraordinary career.

Although Miller did not resolve her personal and creative identities, she did reconcile with Man Ray. They stayed in touch throughout the war, Man Ray endeavouring to lift her low spirits with gifts and letters. The couple were reunited in 1975 at his show at the ICA in London. She visited him every day at his hotel and sat on the bed with him, and to observers they seemed like a happily married old couple. They did not formally rekindle their relationship and Man Ray died a year later, but they had finally found the peace that evaded them in their youth.

Man Ray

Max Ernst

&

Dorothea Tanning

1946–1976

Both Max Ernst and Dorothea Tanning were self-taught artists, surrealists before the fact and escapees of unstable or disciplinarian childhoods. There must have been something profound expressed about their comparative origins when they first met in Tanning's studio in 1942, because Ernst left his wife, packed his spoon collection and moved into Tanning's apartment three weeks later. Ernst was not leaving any ordinary wife; he was married to the great US art patron, collector and dealer Peggy Guggenheim, one of the most influential and distinctive personalities in the art world of Europe and the United States in the first half of the twentieth century.

Guggenheim was a vital supporter of Ernst's work and provided his entry point into New York society. She recalled that she married him as *'I did not like the idea of living in sin with an enemy alie*n.' Ernst was already a well-established avant-garde artist by the time he arrived in New York in 1941. Two of his paintings were included in the Nazi degenerate art exhibition of 1937 and never resurfaced. Ernst served as a young soldier in the First World War and was part of a lost generation that emerged from its horrors alienated from Western society and its values. He expressed his refusal to conform with licentious sexual behaviour and, memorably, joined in the creation of the quasi-cynical, quasi-comical, 'anti-art' movement, Dada. He shocked bourgeois sensibilities with his exhibit in Cologne in 1917, which invited the audience to smash his sculpture with an axe he provided.

In 1922, he moved to Paris where his Dadaism matured into surrealism. Ernst was one of the first artists to mine his subconscious as a subject for art in the wake of reading Sigmund Freud's seminal psychoanalytical work. When Hitler came to power in 1933, Ernst was quickly marked out among a generation of subversive artists who appalled the Führer, making work that did not glorify the state and, worse still, took mental illness or obscenity as its subject. His days were numbered as he fled from the Gestapo, who had previously interned him three times in a prisoner of war camp. Already his patron and lover, Guggenheim secured him a safe passage alongside a host of other avant-garde refugees to the safety of New York.

Tanning had already endeavoured to meet Ernst and the other artists she admired from a distance in 1938 in Paris. She was running in the opposite direction, towards Europe and bohemianism and away from her stiflingly dull childhood in Illinois and fantasist parents. In her memoirs, she recalled that she was born in the middle of a storm, a circumstance that fuelled her own popular legend. At the age of five, she was trussed up to read poetry on stage, precociously performing in tears to the delight of her failed actress mother. She was always an energetic force, alarming her parents with her proto-surrealist style and painting a naked woman with leaves for hair aged just 15. She landed in New York by way of a few interesting gigs in Chicago, where she claimed to have dated a gangster who was murdered mid-dinner and performed as a puppet master at the Chicago World Fair. In New York, she visited the 1936 surrealism exhibition at the Museum of Modern Art (MoMA). It was a breakthrough moment, not because it afforded a new way of seeing but because she had found others who felt the same way:

Dorothea Tanning

'I thought: Gosh! I can go ahead and do what I've always been doing.'
Two years later, Tanning departed for Paris armed with letters of introduction for Ernst, Pablo Picasso and Kees van Dongen. Her trip, however, was fruitless because Paris was already on its knees, and the avant-garde crowd she sought had dispersed and largely fled from the devastating war on the horizon. It was back in New York in 1942 that bohemia finally found her. Julien Levy, a surrealist gallerist who first exhibited Frida Kahlo's work, recognised something in Tanning, too. He took her on and invited her to a party, where she met the lost Parisian crowd now reunited in New York. Auspiciously, Ernst was among them. However, it was Ernst's wife, the art dealer Guggenheim, that gave him a reason to visit Tanning's studio. Guggenheim had committed to curating a pioneering all-women exhibition, '30 Women', a landmark show that is known today by its second title, '31 Women'. Tanning became the 31st artist as Ernst persuaded Guggenheim to include her after his captivating studio visit. Later on, realising that this addition would seal the end of her marriage, Guggenheim dryly stated: *'I should have had 30 women.'*

Despite Tanning's affinity with the surrealist movement after the MoMA exhibition, it was only in 1944 that she had her first solo show as a surrealist artist, at Julien Levy's gallery. The exhibition was a success, but Tanning and Ernst did not stick around in New York to take centre stage as the surrealist 'It' couple: that moniker went to Yves Tanguy and Kay Sage. The desert town of Sedona, Arizona, beckoned the artists away. For Tanning and Ernst, the remote isolated landscapes did not need to be rendered in a surrealist fashion; they were by their very strange and timeless appearance naturally surreal. They fell under the spell of this wild and uncharted land, and also of each other.

Ernst had been married three times before when he met Tanning. Despite their profound bond, the institution of marriage was not something either had a huge amount of respect for. They married in an unusual joint ceremony with fellow artist Man Ray and his wife Juliet Browner in 1946. Tanning later described the wedding as *'painless, forgettable but fun'* and said: *'If you get married you're branded. We could have gone on, Max and I, all our lives without the tag. I never heard him use the word "wife" in regard to me. He was very sorry about that wife thing.'* Clearly, they both knew that her position as a wife to a famous artist, no matter how celebrated she was, would be to her detriment.

Tanning outlived Ernst by 36 years and went on to be the self-titled world's oldest emerging poet. Before her death at the age of 101, she moved on from surrealism and created partly figurative, soft sculptural work that became inspirational for artists such as Louise Bourgeois and Sarah Lucas. She remains a great focus for feminists, a pioneering spirit who brilliantly proclaimed at the age of 80: *'I wish you wouldn't harp on that word, "women". Women artists. There is no such thing – or person. It's just as much a contradiction in terms as "man artist" or "elephant artist". You may be a woman and you may be an artist; but the one is a given and the other is you.'*

Dorothea Tanning

Jasper Johns

&

Robert Rauschenberg

1954–1961

Step into the Cedar Tavern in New York in 1953 and you would find a private world, fusing a liberal measure of whisky, cheap cigarettes and the United States' greatest living painters. Despite the rivalries, goading and occasional bouts of violence, this coming-together of artists served as a pseudo-school, with aspects of an undeclared support group. Robert Rauschenberg recalled being a young artist in this crowd: *'One beer would last six different artist fantasies: Rothko, Barney Newman, Franz Kline, Bill de Kooning and Pollock occasionally.'*

As much as Rauschenberg admired and recognised these trailblazers, who had set New York alight with abstract expressionism, he believed he had to turn away, reject the weight of recent art history and forge new paths. He was not instantly successful in his self-assumed role as the *enfant terrible*. His show of sculptures at the Stable Gallery was ridiculed and he was dispirited, insecure and creatively frustrated. However, it was not one of the artistic elders at the Cedar Tavern who showed him the way forward. Instead, it was a skinny nobody, Jasper Johns, who had just finished serving in the army and wound up in New York selling books. The two became lovers and, within the private boundaries of their affair, entered a vital period of intense productivity that was the catalyst for finding their artistic greatness.

In an artistic climate that was macho and full of testosterone, Rauschenberg and Johns retreated to a world of poetic poverty, living in run-down adjacent apartments on Fulton Street. The building suited Rauschenberg, who was an avid scavenger at the nearby port and incorporated detritus that washed up into his paintings. He was not simply rejecting the art movement that had come before but also social expectations and commitments. He had married the artist Susan Weil in 1950, with whom he had a son, and lived in the Upper West Side. However, he left his wife and son to paint in Italy and Africa with Cy Twombly, who became an artistic sparring partner and lover. His sexuality was fluid and his temperament steadfastly egocentric: everything was sacrificed to foster his creative ambitions.

Johns was the opposite of ruthless. Compared with Rauschenberg, the gregarious and high-spirited raconteur, Johns was introverted: a deep thinker who watched rather than performed. Johns may have lacked Rauschenberg's artistic pedigree – he had studied in a Parisian Academy and then under the founder of the Bauhaus movement, Josef Albers, in North Carolina – but he compensated with a fine intellectual mind, well versed in philosophy and literature. Rauschenberg encouraged Johns to paint, and in return Johns

Jasper Johns' and Robert Rauschenberg's work often transformed well-known symbols and motifs into symbolic and coded abstractions.

gave his lover a secure ground to reinvent himself. The freedom to work with reckless abandon was clearly a daily privilege for both men in Fulton Street. In their six fertile years, forever skirting poverty and exposure of their affair, they each made the most seminal and career-defining work of their lives.

In 1954, soon after Johns became his lover, Rauschenberg started to create what became known as 'Combines'. He borrowed the painterly language of abstract expressionism in large works mounted on board, but added scraps of newspaper clippings, photographs, fabric and other people's drawings or paintings in a highly textured, obscure set of configurations. On the one hand, they ridiculed the supposed god-like status of abstract expressionist painters seeking transcendence, by incorporating mundane tatty slices of unknown origin. On the other hand, they were deeply personal, symbolic and coded, and full of inaccessible meaning and longing. In *Untitled* (1955), Rauschenberg included disguised letters from Johns, a drawing from his former lover Twombly, newspaper clippings, references to his son and a drawing of the American flag.

The American flag was also found in the work of his lover Johns. And in fact, so successful and committed was Johns' work with motif that in some sense no one else in the history of art will ever be able to use the flag without acknowledging Johns' artistic possession of the image. He revisited the motif around 40 times; it was in his bookish nature to rework the same idea obsessively. In the same way that one can repeatedly write or say a word out loud so many times that the word loses its meaning and appears to be a nonsense, the same thing happened with Johns' flag. At first glance, his work from 1958 could be mistaken for being a real flag from across a room, but closer inspection reveals that, although the proportions are correct, it is created with thick, almost creepy re-rendering in encaustic layers, over and over. At what point does it stop being the all-American symbol? Can it ever lose its sincerity as an emblem?

The work Johns was making was obsessive and potent in its brilliance. He was conjuring icons and mysteries, both distilling and complicating, painting and collaging. Leo Castelli was the world's most successful art dealer when he saw the work hoarded in Johns' shabby apartment, and he immediately signed him for a solo show. Legend has it that Rauschenberg casually took the dealer to visit his neighbour to beg some ice for a drink. In generously introducing his lover, the unknown genius artist, to Castelli, he might have sealed the end of their affair.

Rauschenberg's planned exhibition was forgotten and Johns' paintings, which transformed symbols (flags and targets) into abstractions, were an instant success. His first solo show sold out and the Museum of Modern Art acquired work, thus sealing his transformation from undistinguished bookseller to enigmatic painting star. Their relationship, once so private and healthy in its artistic camaraderie, did not survive the spotlight and jealous tensions quickly bubbled to the surface. They split in the early 1960s. Rauschenberg would eventually find the accolades he desired, and each would be a permanent fixture of the art establishment.

In a rare comment on the relationship, Rauschenberg addressed it poignantly: *'I'm not frightened of the affection that Jasper and I had, both personally and as working artists. I don't see any sin or conflict in those days when each of us was the most important person in the other's life.'* He accepted that they parted ways over *'embarrassment about being well known . . . What had been tender and sensitive became gossip. It was sort of new to the art world that the two most well-known, up and coming studs were affectionately involved.'*

The artists did not orbit very far from each other, despite not speaking for many years after the break-up. Theirs was a small New York scene, where broken love affairs, bitter rivalries and intense antagonism had no space to breathe. They may have persisted in silence, but there was no way either man would have been able to forget the other's extraordinary impact on his work. In those few years in Fulton Street, they became the artists they were destined to be in a fertile landscape of their joint imagination.

Robert Rauschenberg

Elaine de Kooning

&

Willem de Kooning

1938–1989

In 1962, Elaine de Kooning was commissioned to create a portrait of John F Kennedy.

The lives of Elaine and Willem de Kooning were battle scarred. By the time they each arrived in New York's nascent art scene as young adults, they were already wounded from familial relations. They both fought to find their artistic voice and were enthralled by the possibilities of the human figure, kicking against the prevailing trend for abstraction. Together, they struggled with extreme poverty, battled the ravages of alcoholism and endured endemic infidelity on both sides. And yet, in the face of constant war with themselves, the art world and each other, they left behind an important body of work and extraordinary legacies, and never divorced. Emotionally reckless and tumultuous as it may have been, disadvantageous at times and often unpleasant to those in their orbit, the de Koonings' marriage took many blows but did not capitulate.

The de Koonings were never going to have a placid relationship as they were opposites in almost every regard, the singular exception being their commitment to dedicating themselves to great art. Elaine was tall with fine features and a good head of red hair. Willem was well built but shorter, a compact Dutchman with rough good looks. He was charismatic but could be gloomy, and when it came to his work he was anxious and self-obsessed. Elaine was gregarious, generous of spirit, flirtatious, socially vivacious and never seen without a cigarette.

Born in Rotterdam in 1904, Willem, whose surname means 'the king' in Dutch, arrived in New York in 1926 without telling a soul he was leaving nor bringing a single possession with him. In his bid to fulfil his childhood ambition of being a great artist, he paid a huge price: he spent the rest of his life evading the expectations of a settled family life. He was recognised as a natural talent as a child, and at the age of 12 was an apprentice to a prestigious decorating firm. He enrolled in art classes, which were both a blessing and a curse in their dogmatic insistence on working directly from life without inventions or short cuts. He honed his gift for draughtsmanship into something sublime, forced to work 600 hours on one single still-life. De Kooning developed an extraordinary talent for realism, which he carried around like a burden in the avant-garde New York art scene bursting with the joys of abstraction.

Elaine was born Elaine Fried in Brooklyn in 1918, the eldest of four children. What her eccentric mother lacked in love, she made up for in a solid arts education, regularly taking her favourite daughter, whom she nicknamed 'Samson', signifying strength, to the Metropolitan Museum of Art. Elaine's room was filled with posters of great artists and her passion for making portraits saw her through a difficult childhood, after she became a surrogate parent to her siblings when her mother was forcibly removed from the home and placed in psychiatric care for a prolonged period.

As an 18-year-old arriving in New York to develop her arts education, Elaine was hardened to the world and prepared to commit herself to painting, no matter the cost. She was introduced to Willem, 14 years her senior, by her art teacher in 1938. They fell in love immediately: Willem recalling how smitten he was and what beautiful hair she had, and Elaine

Willem de Kooning

74

later saying she married him as someone told her he was going to be the greatest artist. Their wedding seems to have been something of a formality to avoid the burden of Elaine's long commute to Brooklyn. They lived without any financial assistance, Willem drolly repeating: *'I am not poor, I am broke',* and when either made a few dollars – Elaine modelling for artists or Willem reluctantly selling a painting he was almost happy with – they would often have to decide between food and cigarettes. Despite their depleted economic circumstances, socially and culturally they felt rich. They were at the centre of a boisterous, energetic new art scene, centred on the Cedar Tavern and featuring a cast of future greats: Jackson Pollock, Lee Krasner, Mark Rothko, Franz Kline and others.

In the late 1930s and 1940s, it was clear to everyone that Willem was destined for great things: he was a serious, authentic and brooding talent with such high standards that he destroyed more art than he finished. In his struggle to break from the rigours of his training, he moved closer and closer to a less self-conscious way of painting. Abstraction helped him with this, although he never entirely gave up figuration: for him, the human form had a power that could not be extinguished. By the late 1940s, witnessing the ascendency of Pollock's 'drip' paintings, Willem began to feel more at ease in his work and allowed himself to *'go to town'*. He had finally found his style, and 20 years after arriving in New York had his first solo show with his great

friend Charles Egan in 1947. Success followed soon after and de Kooning spectacularly fulfilled on his early promise.

His artistic success arrived in the death throes of his relationship with Elaine. The de Koonings had enjoyed a short-lived period of happiness in the early years of marriage, followed by years of fighting, alcoholism and constant affairs. Shortly before Willem's solo show, Elaine began a relationship with Egan. Apparently, Willem was able to continue the gallery arrangement regardless. Monogamy within the social world they inhabited was not widely respected or upheld, and the de Koonings were probably the most extreme in this regard. By 1957, the relationship was so bruised it was impossible to continue and the couple separated, although Elaine remained as great a champion of her husband's work as she had always been.

It was in the years after leaving the marriage that Elaine enjoyed success; one cannot help but wonder if she might have done so earlier had she not been Mrs Willem de Kooning. In 1962, she was commissioned to create a portrait of John F Kennedy, an enormous vote of confidence in a painter who belonged to uncharted bohemian territory in the eyes of the conservative elite. In her characteristic fashion, she made multiple images in quick succession, confident in her pursuit of character through the human figure's movement and pose. Unlike Willem, she worked fast and without trepidation. As well as working from life with the president, she avidly collected magazine clippings and sketched him on the television. His image pulsated in her studio, and when he was assassinated a year after she began her commission she was so devastated that she did not make any further work for a year.

By 1959, Willem was an artistic hero with an international reputation. In the Cold War era, the United States sent his work overseas to speak of all that was free and brilliant: he was the Pied Piper of the New York art scene. Like his now-dead artistic rival Pollock, he was ill equipped to deal with the success he craved and sank further into alcoholism and depression. At his bleakest moment, Elaine walked back into his life and together they moved to Long Island and he joined Alcoholics Anonymous, which probably saved his life. Separated for nearly 20 years, Elaine was well travelled and brought new cultural references to her already well-versed painting practice. She was also a respected art teacher. Now much older, the de Koonings finally stopped fighting each other and the art world, and made art side by side for two decades. Elaine's work has been increasingly appreciated in recent years as scholars try to extract her from Willem's shadow. The repositioning is valid, but Elaine never resented her former position, asserting late in life that she was not in his shadow: *'I was in his light.'*

The couple had found peace together, but the battle was not entirely over. Elaine was diagnosed with cancer in the early 1980s and endured ill health for many years. Willem, who had been an introvert locked inside his studio his whole life, sealed his isolation as dementia took hold of him. When Elaine died in 1989, he was not informed. He died aged 92, outliving his artistic compatriots who built the New York art world alongside him and his gregarious and brilliant wife.

Maria Martins

&

Marcel Duchamp

1946–1951

Marcel Duchamp is considered to be the most influential artist of the twentieth century. Pablo Picasso may be the greatest, but he is a breed of singular genius, someone to be admired, feared and respected but not openly emulated. Duchamp, on the other hand, opened doors for artists in his wake: he redrew the lines, changed the game and detonated Pandora's box. After Duchamp, anything could be art if the artist said so. His iconic work *Fountain* (1917) was a ready-made: a pre-existing object (a urinal) re-purposed as art by the artist's simple act of signing and re-presenting it. Duchamp, by asserting *'I don't believe in art, I believe in the artist',* became a postmodern hero, a figure who challenged conventional ways of thinking, who disrupted the natural order of art history, arguing: *'If one is logical, one doubts the history of art.'* He does not fit the model of the romantic artist, the tortured genius, the insecure soul looking for validation for their creative endeavours. Rather, we think of him as deeply cynical, standoffish, perhaps even calculating, but certainly mischievous.

How, then, is he the same man who writes like a wounded teenage boy in his love letters to his secret lover, the Brazilian sculptor Maria Martins? *'My love I think of you always. But the 14 hours a day I don't spend with you are a torment to me.'* When apart from Martins, he feels as if *'life is empty, the city is empty . . . isolation hurts'*. The depth of feeling in his letters was only made public when the correspondence between the lovers was auctioned at Sotheby's Paris in 2006 and later included in an exhibition catalogue by the Philadelphia Museum of Art in 2009.

Duchamp divorced his first wife in 1927 after only six months of marriage, recoiling from the pressures of societal expectation. He met Martins in 1943 in New York. She was the wife of the Brazilian Ambassador to the United States, a liberal and provocative character who wielded her sexuality like a well-practised dancer. She saw herself as a femme fatale and certainly expressed her love in fiery terms. A poem she wrote Duchamp plays with the pleasure/pain principle:

> *For a long time even after my death*
> *For a long time after your death*
> *I want to torture you*
> *I want the thought of me like a flaming serpent*
> *to coil around your body without burning you*

*I want to see you lost, asphyxiated,
wandering in the mist . . .*

Martins' artwork displays a similar preoccupation with power, sensual forms, torment and suffering. Her sculptures grew out of surrealism and incorporated highly expressionistic, personal themes. Often fusing human, plant and animal forms, she created hybrid creatures. Martins, who was in debt to artists such as Max Ernst and Alberto Giacometti, had a peculiar talent for distorting form, as seen in *Without Echo* (1943), which recalls the ancient sculpture *Laocoön* and its desperate twisting figures fighting off serpents. However, in the hands of Martins, the presentation transpires to be a single female form, curvaceously organic but with threatening claw-like features that seem to turn in on themselves.

In New York in 1943, Martins exhibited her work in a joint show with the Dutch pioneer of the De Stijl movement, Piet Mondrian. In a rare reversal of the usual side-lining of women artists, Martins' work sold and Mondrian's did not. She bought what is now considered a key work by Mondrian, *Broadway Boogie Woogie* (1942–43) for $800, and later donated it to the Museum of Modern Art in New York. It is tempting to imagine Duchamp waltzing into her exhibition wearing the crown of one of the most influential living artists. They did meet at the gallery, but Duchamp was apparently no longer considered an artist by 1943. From the 1920s, Duchamp stopped presenting artwork and focused solely on chess. It is a rare example of a potent artistic force retiring itself, and it was only from the late 1950s onwards that his great significance to art history was championed by a younger generation of artists, such as Robert Rauschenberg and Jasper Johns.

As usual with Duchamp, not everything was as it seemed, for he was the master of contradiction. It was not until after his death in 1968 that his final beguiling masterpiece was revealed, which had secretly occupied the last two decades of his life. *Étant Donnés* (1946–66) is an erotic assemblage, an unsettling stage-like scene of a nude with her legs splayed, which can only be viewed through peep holes. Johns called it *'the strangest work*

of art in any museum'. It is only in recent decades that the significance of Martins in this final artwork has been understood. Or rather, one could argue that it is in recent years that the artwork has been better understood due to the insight provided by the artists' erotic and powerful relationship.

Duchamp and Martins' short affair lasted between 1946 and 1951, at which point Martins left a devastated Duchamp to return to Brazil. In his past, he had broken the hearts of many women, but it seems with Martins he met his match. She was seductive, powerful and reckless by the standards of the day for women, conducting affairs despite her high social standing and three children. They made an odd pairing in some ways: Duchamp was reclusive and Martins extremely sociable and gregarious. He begged her to take the available studio next to his on West 14th Street so that they might have a lovers' den, but she refused. She was not going to be shut in, even with an artistic genius. During their potent relationship, Duchamp created erotic objects, paintings with semen and collages that included body hair. His underground art practice was entwined with his love for Martins. *Étant Donnés* was largely modelled on her body. He made detailed pencil drawings of her nude figure and plaster casts of her body and modelled the highly naturalistic skin on hers. She was also a collaborator in a sense, as Duchamp consulted her frequently about the work. It seems as if only Martins and later Duchamp's second wife, Teeny, knew of the artwork's existence.

Étant Donnés is the subject of endless interpretation and speculation. Conservative audiences were appalled when it was presented, confused as to its tone and meaning and sometimes reading it as the aftermath of murder or rape. Others understand the piece in the context of Duchamp's lifelong inquiry into voyeurism, metamorphosis, the machine, the body and the site at which they all meet. One thing is clear from both the letters the couple exchanged and the artwork they each created, Duchamp and Martins were jointly intoxicated by power, eroticism and the torments of love.

Maria Martins

79

Marcel Duchamp's Étant Donnés *was largely modelled on Maria Martins' body.*

Marcel Duchamp

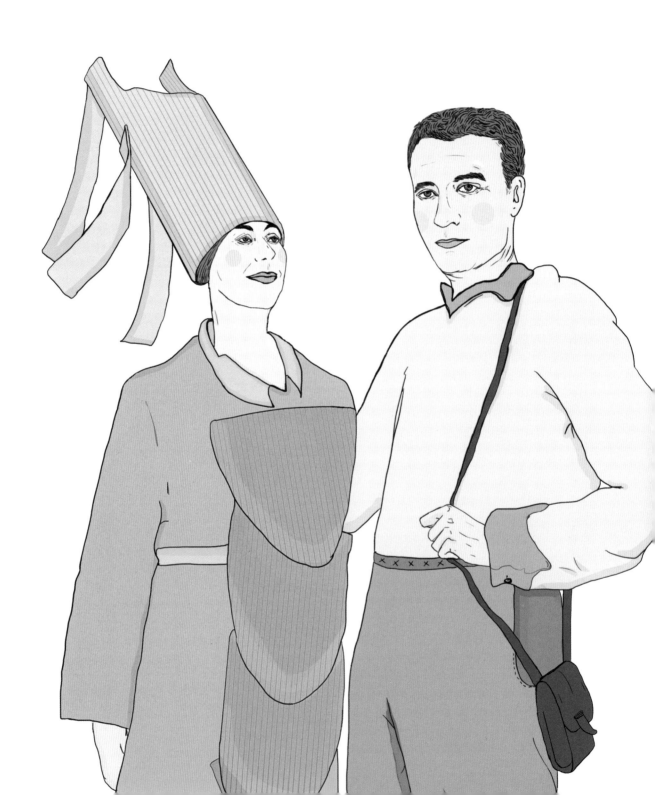

Hans Arp

&

Sophie Taeuber-Arp

1915–1943

For a group of young creatives and intellectuals, the First World War marked the end of the civilisation of Europe as they knew it. They perceived the blood baths in the trenches and the deaths of millions of young men, as neighbouring countries tore each other apart, to be an absolute break with the past. The high culture and supposed enlightened values of Europe slipped away, and what was left was a void, a betrayal of values, a cynicism and a complete mistrust of everything collectively built and systematically destroyed by the worst conflict in human history.

These sentiments found room for expression in a small neutral pocket of Europe, Zurich. Hundreds of artists and writers, avoiding conscription and the horrors of war, sought safety and resistance. Their coming-together in the famed Cabaret Voltaire nightclub created a potent blend of rage, despair, madness, hedonism and reckless joy. Out of this tiny but loud community, one of the most significant and strange movements in twentieth-century art was born: Dada. Two of its brightest stars were founding members Sophie Taeuber-Arp and Hans Arp.

Dada is a nonsense word, sounding like the noise a baby makes or the beat of a drum. The name of the movement encapsulated its rejection of authority, appreciation of childishness and noisy, boisterous nature. It was also the password to gain access to the Cabaret Voltaire. After uttering the word, which stood for the celebration of the irrational and the dissolution of all social, cultural and moral values of the past, visitors would enter a nascent world bursting with energy as it rewrote its own rules. Once inside the haven for artists, they would encounter wild poetry, nonsensical music, exhibitions of abstract art or perhaps even the uninhibited dancing of Taeuber-Arp, as she wildly moved her legs in a trance-like semi-fugue, wearing extraordinary masks she had made for these proto-performance art pieces. She held the room captive, including Hans Arp who later declared her his soulmate and most important artistic collaborator.

In their collaboration and independent practices, the artists were years ahead of their time. Born in 1889, Taeuber-Arp was Swiss and trained as both an artist and a designer. She endeavoured to use the social and artistic freedoms that Dada encompassed to overcome her second-class position as a woman and to diminish the boundaries between so-called 'craft' and fine art. She may not have entirely succeeded in her lifetime, but today she is considered one of the most potent creative forces of her period, leaving a vital legacy for future generations.

Arp was born in 1886 in Alsace, which had been recently annexed to Germany as a result of the Franco-Prussian War. He was neither fully German nor French: his parents gave him a name for each nation and he switched between Jean and Hans, as well as between French and German, depending on his audience. Inhabiting a multi-lingual world and, in a way, being born between two places, Arp was particularly sensitive to the changing of borders and the pursuit of militaristic expansion. He arrived in Zurich in 1915 after the war began, having left Paris where he had lived on and off and been usefully connected within avant-garde artistic circles.

Arp was already exploring abstract art by this time. Working across a range of media, but rejecting the tradition of oil painting, he consistently employed a kind of organic quality in his abstraction: his biomorphic wavy lines and curvaceous forms are easily relatable to motifs found in nature. Although a recent arrival to Zurich, by November 1915 he was already exhibiting work at a group show at Galerie Tanner – *'modern tapestries, embroidery, paintings and drawings'* – and it was in this moment of avant-garde display that he met his future wife, who shared his unconventional stance. He was 29 years old and she 26.

Their mutual belief was in, as expressed by Arp, *'the total negation of everything that had existed before . . . the role of chance, not as an extension of the scope of art, but as a principle of dissolution and anarchy.'* Together, they made collages, still a new and innovative medium, but they rejected the use of scissors and cutting and pasting by hand. Inspired by the concurrent atmosphere of chaos and celebration of randomness over rules, they dropped scraps of paper haphazardly and allowed chance to dictate where they would paste them. They entered a new terrain in art history, eliminating conscious thought and instead pursuing something they saw as pure in its spontaneity because it belonged to a spiritual, irrational artistry engaging with chance, as opposed to being beholden to a thinking mind, which they believed dulled the possibilities of pure, unbridled human creativity.

On the opening night of the Dada Gallery in 1917, which one imagines was a wild and hedonistic affair, Taeuber-Arp performed wearing a costume designed by Arp. Her mobility was restricted by his creation, thus causing jerking, abstract, intuitive movements: she was pure Dada in motion. She celebrated art in all its forms, through tapestry, dance, interior design, puppetry, and set and clothing design, and the idea that it might be functional and part of everyday life did not diminish her belief that it had a vital political and social role to play. Indeed, she was exceptionally open minded, nourishing

a vision of life in which art was paramount in magnitude but also found in every corner.

Taeuber-Arp held important teaching positions and was commercially successful. In 1926, she was commissioned alongside her husband and the Dutch abstract artist Theo van Doesburg to create designs for Café Aubette in Strasbourg, an eighteenth-century building with a large dining room, cinema and dance halls. Their fusion of applied textile design and architectural refurbishment became known as the Sistine Chapel of abstract art, and today would be a crucial place of art historical pilgrimage if it were not for the fact that it was deeply unpopular with conservative residents and was reworked before later being bombed by the Nazis.

Arp is today celebrated as a one-man movement, creating a bridge between Dada and surrealism and winning prestigious prizes and museum accolades in his lifetime. His wife did not live to see the international success she deserved. Tragically, she died aged 54 from accidental carbon monoxide poisoning after staying with friends who had a faulty oven. Arp retreated to a monastery in despair for a period after her death. When he returned to his practice, he began to make collages by cutting up his own work and also the drawings he had made with his late wife. The act of reassembling her work into his helped rekindle his creativity. Largely thanks to Arp's efforts to preserve and exhibit his wife's work, today Taeuber-Arp is slowly receiving her share of recognition as being one of the most influential forces in twentieth-century art. She was honoured with a Google doodle on her 127th birthday and became the first woman to appear on a Swiss banknote. Performance artists the world over, punks and those endeavouring to fuse art with life have all walked through a door that Sophie and Hans opened for them more than a century ago.

Hans Arp and Sophie Tauber-Arp, along with Theo van Doesburg, were commissioned to create designs for Café Aubette in Strasbourg.

Raoul Hausmann

&

Hannah Höch

1915–1922

If there could be only one artwork to represent the society, politics and art world of Germany in 1919, then a strong contender would be the photographic collage titled *Cut with the Dada Kitchen Knife through the Last Weimar Beer-Belly Cultural Epoch in Germany* (1919). The large photomontage is a cornucopia of found imagery and words cut from magazines, pamphlets and newspapers. Reassembled with exacting intention, the artwork juxtaposes recognisable political figures, such as the president of the German Reich and the deposed Emperor Wilhelm II, with the intellectuals Karl Marx and Albert Einstein, interspersed with a healthy dose of film stars, sports heroes, dancers and contemporary bohemian artists. Here, the Weimar Republic is shown to be a mass of contradictions: fuelled by modern technology but undone by hedonism; fashionable yet ridiculous; intellectually pioneering but mired with mass demonstrations.

It is an icon of its era and one of the greatest works of art to emerge from the Berlin Dada movement, a group of self-professed anti-artists who joined the anarchic spirit of Dada that was originally founded in Zurich during the First World War. Enraged by the staggering loss of life and extreme distrust of government, these artists rejected all that was conservative, militaristic and conventional, even scorning the seriousness of history and its art. A photograph taken at the First International Dada Fair in 1920 shows the Berlin Dadaists, a fantastic-looking group of counter-culturals, posing amid the art chaos around them. The creator of the staggering collage is there: she is Hannah Höch, pictured with a cane and fashionably short hair next to her love interest, the already married Dada artist Raoul Hausmann.

Höch was one of very few women associated with the group and she is today considered one of its most talented voices. The Dada spirit of questioning authority, dismantling the systems of the past and rejoicing in divergence meant that its manifesto supported gender equality. Society was changing: the concept of the modern woman emerged in the 1920s, celebrating a fresh era in which women were newly visible in the

workplace and in the streets. No longer confined to the home, they became a symbol of the new metropolis and its spirit of progress. Fashion magazines spoke directly to the modern woman, selling her flapper dresses, short haircuts and androgynous silhouettes.

But to associate Höch with this pre-packaged modern woman would be a serious under-estimation. She questioned everything, and in her art revealed a distinct mistrust of the new modern woman. Dada might have professed emancipation for women, but its principles were simply rhetoric. Höch's male colleagues tried to have her piece removed from the exhibition and it only remained at the insistence of Hausmann, who threatened to walk if the collage was not included. This was not an act of lover's mercy; even at the time the piece was singled out by a reviewer of the exhibition as exceptional and Höch continued to make huge contributions to Berlin Dada. However, on various occasions, the men in her avant-garde circle actively tried to marginalise her. Hans Richter dubbed her the 'good girl' of the group, and the artists who later wrote memoirs either mentioned her patronisingly, as providing excellent refreshments, or omitted her presence completely.

Hausmann may have stood up for his lover in 1920, but he was as guilty as the rest were of subjugating Höch. The couple endured a turbulent relationship, which often descended into blazing rows and violence. They met in Berlin in 1915, when Höch was 22 years old and Hausmann, a Czech émigré three years her senior, had already been married for seven years to a violinist with whom he had a daughter. Hausmann was charismatic, opinionated and well entrenched in the Berlin art world, but his charm quickly gave way to a short temper and egotistical nature. Höch presumably knew the relationship might be ill fated, later describing it as almost reckless, but despite its tensions it afforded them both an extremely fertile period creatively. During the seven years Höch and Hausmann were together, they created the pioneering photomontage technique that became a pivotal development for Dada and provided a

new language for radical ideas.

While enjoying a holiday on the Baltic Coast, a welcome prolonged period in each other's company away from Hausmann's wife and child, the artists were struck by an unusual image in their guest house. The owner had taken a generic picture of five soldiers and stuck a portrait of his son on each body. This strange concoction, presumably created from a parent's anxiety about a son serving in the army, was a eureka moment for Hausmann and Höch. Photomontage allowed both artists to reconfigure imagery, cutting and splicing their way to detached commentaries on society and politics with wit, irony and brutality. By using the very stuff of society, its mass-produced materials for easy consumption, photomontage created a dialogue about the way the Weimar Republic saw itself. Their work was hugely influential in the group and proved an endless source of expression for Dada thinking.

The couple were at the centre of the Dada Berlin circle, attending events and exhibitions and living against the prevailing social conventions of the time. Hausmann espoused beliefs that capitalism and family hierarchy were inherently patriarchal and that women should resist marriage to be fully emancipated. Partially at odds with this theory, he also believed it was every woman's destiny to have a child. Höch was still keen to have children, but she knew society would not condone this of an unmarried woman and was increasingly frustrated by her lover's refusal to leave his wife. Hausmann revealed himself to be a hypocrite, though: he sneered at Höch's bourgeois sentiment that marriage was important but was appalled at the prospect of divorce for himself.

Hausmann was also disparaging about Höch's opinions on art. Dada believed in the complete rejection of all that had gone before, but Höch was still painting easel still-lifes and landscapes. She took a more moderate approach and was detached from the flamboyant Dada performances and riotous behaviour designed to scandalise in the name of anti-art. While her male counterparts worked entirely under the banner of opposition and aimed for outrage, her work was

Raoul Hausmann

Hannah Höch's photographic collage Cut with the Dada Kitchen Knife through the Last Weimar Beer-Belly Epoch in Germany *is a cornucopia of found imagery and words cut from magazines, pamphlets and newspapers.*

often ambiguous and personal and still highly valued form, composition and craft.

Höch's ambivalence about Dada's gimmicks should not be mistaken for a lack of courage; she was making pointed attacks on society's obsession with the modern woman in her photomontage work and also satirised the smug vanity of her fellow male Dada artists in *Da-Dandy* (1919). She went even closer to the bone with her short story 'The Painter' (1920), which lampoons her lover by describing a man who has a mental and spiritual crisis because his wife asks him to do the washing up. By 1922, Höch was bored of Hausmann's hypocrisy and fragile ego, revealing: *'He needed constant encouragement to carry out his ideas and achieve anything at all lasting.'* After a second abortion she would rather not have undergone, Höch left him.

She later visited her former partner, who by the late 1920s had effectively sold out on his ideals by becoming a society photographer. She described him as *'boring. All he talks about is the things he can now afford to buy.'* In contrast, Höch's potency was far from extinguished. For more than half a century, she continued to make photomontage work, evolving from her formative Dada years into a hugely influential artist who made a staggering range of work that encompassed abstraction, fantasy, feminism and biting social satire. She enjoyed a long, highly productive career. Having been marginalised in her youth and having had her work ignored for decades, she was honoured two years before she died with retrospective exhibitions in Paris and Berlin in 1976.

Today, her work seems even more relevant in an age that is saturated with digital imagery and she has reclaimed her place as a key figure in twentieth-century art. By refusing to conform to the non-conformists, Höch outlived the brevity of Dada and, as the 'good girl', she made her former lover and the Dada men look like boys.

Hannah Höch

Josef Albers

&

Anni Albers

1922–1976

The Bauhaus school is far more than a building; it is an unprejudiced philosophy fusing art, craft, design and manufacture to create a 'total' work of art with such a profound legacy that its intrinsic nature in our modern world is almost invisible. Founded in 1919 in Weimar, Germany, by Walter Gropius, the Bauhaus' principal design ethos came to be one of a singular dedication to functionality. Past tenants of decoration, elitism and expressionism were gradually eschewed in favour of a clean slate that valued functionality above all and an equality between all art forms. The exposed concrete, sleek modernism and steel furniture, which populate our surroundings today, were born from the pioneering work undertaken at the Bauhaus. The school was radical, and lessons were designed to strip away past education, taste and aesthetics to be able to emerge naked and ready to rethink everything.

If Bauhaus were a religion, two of its greatest prophets would be Anni and Josef Albers,

who became leading innovators of modernist abstraction. Josef enrolled in 1920, when the school was one year old, and Anni two years later, when the Bauhaus was impoverished and still organising itself. At the Bauhaus Christmas party, Gropius handed out presents dressed as Father Christmas, a wonderfully off-duty image for a man today regarded as one of the cultural geniuses of the twentieth century. Anni was delightfully surprised to be given a print of Giotto's *Flight Into Egypt* (1304-06), with a hand-written note from her admirer, Josef. They were quickly infatuated, despite hailing from very different backgrounds. Josef was a house painter's son from a mining town, whereas Anni was from a wealthy and respected publishing dynasty and grew up with a governess and a house full of staff. Josef was 11 years her senior and Anni described him as *'a lean, half-starved Westphalian'* with *'irresistible blonde bangs'*. Despite their social differences, the pair fell in love with each other's philosophy, and for

the rest of their lives would be committed zealous proponents of a life and art of pure form.

As a student, Josef worked across many media, trying his hand at sandblasted glass, furniture design, making household objects and designing an alphabet. Anni, on the other hand, was restricted to working in the weaving workshop. The Bauhaus promoted equal opportunities between the sexes but, disappointingly for Anni, discouraged women from undertaking any studies that were deemed physically strenuous. Fortunately, she stumbled into a field that not only was she deeply passionate about, but also for which she would set new standards for generations to come.

Impressive from the outset, Josef was the first student to become a teacher at the school, taking up his position in 1925 and marrying his Bauhaus sweetheart in Berlin the same year. Shortly after the Albers were married, the school moved into a revolutionary new building designed by Gropius,

which became emblematic of the Bauhaus philosophy and growing recognition. The Albers lived in a master's house designed by Gropius and socialised with their colleagues Paul Klee and Wassily Kandinsky and their wives, building a utopian community that stood for progressive education and new values.

Together, they set about a vigorous rejection of bourgeois tendencies towards fuss and unnecessary detail in both life and design. This was perhaps easier for Josef, who later revealed his relief at not being born into a family of intellectuals: *'It would have taken me years to get rid of all their ideas and see things as they are.'* Anni, on the other hand, was born into a more refined family. To her parents, enrolling at a modernist school where her boarding house permitted her one bath a week was an act of genuine rebellion. Anni was conscious that her background should not betray her, and insisted that any visiting family members park

their fine automobiles out of sight. Such was their commitment to restraint, harmony and functionality that they banned balls of butter – a common dinner table flourish – when they hosted their colleagues for dinner.

Anni's first choice may not have been weaving, which became known as the 'women's workshop', but it was to the great advantage of the school and the field subsequently that she threw herself into the medium: by 1931, she was head of the workshop. Anni quickly solved practical and design challenges to create revolutionary new work that firmly cemented textiles into a fine art form. She was a great champion of her medium, recalling how she had heard her teacher, Paul Klee, say: *'Take a line for a walk, and I thought, "I will take thread everywhere I can."'* She quickly adapted his richly colourful, symbolic paintings and developed her own abstract woven artworks. Weaving is slow work, and her pieces were created with great sensitivity to texture and geometric forms, emphasising the artist's hand and touch. She explained that her *raison d'être*

was *'to let the threads be articulate again and find a form for themselves to no other end than their own orchestration, not to be sat on, walked on, only to be looked at'.*

When the Third Reich arrived in 1933, the school closed its doors. Josef, by then an established artist and prominent figure in the faculty, made the decision with his fellow teachers that they would rather terminate the Bauhaus with integrity intact than be subject to the demands of the Nazis. As a Jewish woman, Anni wanted to leave Germany altogether, and the couple were invited to take up positions as founding faculty members at Black Mountain College, an experimental art school in North Carolina.

Anni taught weaving and continued to elevate the form, once seen as women's craft work, into a respected fine art domain. In her seminal text *On Weaving*, published in 1965, she created a survey of the history of world weaving and connected its ancient past with a new validity for the modern world. Josef led the art department and was an instrumental force for a young generation

Josef Albers

Anni Albers championed weaving, elevating it from 'women's work' into fine abstract woven pieces. Josef Albers created a staggering series of more than 2,000 abstract paintings for his Homage to the Square *series.*

of artists, including Cy Twombly, Robert Rauschenberg and Donald Judd. In 1949, Josef took up the position of chairman of the design department at Yale University, which cemented him as one of the most influential art teachers of the twentieth century. He pushed the boundaries of what an arts education could be, and his tactics of drawing with the non-dominant hand, reliance on observation and perpetual experimentation remain fundamental aspects of art schools today. Although he was poorly spoken in English, announcing to his students: *'I want to make open the eyes',* his instruction was so intuitive and performative that he always conveyed his meaning despite his language limitations.

At Yale University, Josef also confirmed his status as a master of abstract painting, working on his *Homage to the Square*, a series of more than 2,000 paintings created over 25 years that demonstrate the endless optical effects available simply by confining colour variants to a square. Josef's pioneering painting was well recognised in his lifetime, and in 1971 he became the first living artist to be the subject of a retrospective at the Metropolitan Museum of Art. However, he was not the first Albers to have a major museum solo show. In a pleasant reversal of fortune for women artists, in 1949 Anni became the first textile artist to be honoured with a solo show at the Museum of Modern Art.

The Albers' heyday as artists was during mid-century modernism in the United States, and despite the changing trends of the art world – away from the kind of reductive, cool, formalist work they made – the couple stayed true to their faith. They were wholly authentic, committed artists who upheld the ideals they formed in the 1920s. The Bauhaus may have resigned itself to closing its doors, but the experiment lived on in these evangelists. Josef died in 1976 and Anni followed him much later, in 1994, passing away on the anniversary of their wedding. She was buried next to Josef in a joint site they had selected together. Although their work fell out of fashion for a time, the zeitgeist has swung back in their favour and in recent years dozens of exhibitions have put them back on the table, a table pure of form and with no swirls of butter.

Anni Albers

Gwendolyn Knight

&

Jacob Lawrence

1934–2000

Between the two world wars, Harlem in New York City became a fertile cradle for an explosion of African American culture. The Harlem Renaissance saw the coming-together of artists, musicians, poets, playwrights, writers and intellectuals, who each contributed to a new creative expression of the black experience. This rebirth and consolidation of African American culture was a result of a historic exodus from the segregated South. The dramatic shift in population saw more than 1 million African Americans depart Jim Crow oppression to seek a better life. During the First World War, industrialised cities such as New York were a beacon for unskilled labourers, and new communities emerged almost overnight. Harlem was previously an exclusive New York suburb, but as the demographic changed the white population left, leaving it to become an incubator for recently migrated residents.

Harlem was its own cultural Mecca within the wider New York art scene, appreciated by white intellectuals and art lovers who joined the throng to absorb the vitality and originality of Fats Waller, Duke Ellington, Josephine Baker and Langston Hughes. These, and other key figures in the Harlem Renaissance, were the first black Americans to receive mainstream recognition, surely a sign of progress in race relations. There is, however, a tendency to romanticise this moment in time. The idea of jazz, theatre, poetry and painting coalescing into something respected in Harlem and beyond provides a soothing tonic in the face of an otherwise brutal African American history. But tense racial inequality, poor living conditions and extreme economic instability were a permanent backdrop, and perhaps impetus, to the cultural revitalisation. Two artists synonymous with the Harlem Renaissance, Gwendolyn Knight and Jacob Lawrence, attest to the complexities of the period and its legacy. The artists had very different backgrounds and, despite being inseparably married for over six decades, continued to have a very different experience of the same environment.

Lawrence was part of the momentous exodus from the South; his parents had reached Atlantic City by the time he was born in 1917. The promise of a better life dissolved quickly when Lawrence's father left his mother and she was forced to put him in foster care while she sought employment. Lawrence was 13 years old when he arrived in Harlem. Now reunited with his mother, she left him at the Utopia Children's Center every day while she worked as a cleaner. In this creative refuge from his unsettled and poverty-stricken childhood, Lawrence met Charles Alston, a key figure of the Harlem Renaissance, who championed the young boy's painting talent and became his mentor. Lawrence began painting the stark reality of the environment around him and buried himself in African American history, absorbing as much as he could about slavery, migration and social injustice.

Knight's heritage was not Southern nor underprivileged like her future husband's. Her mother was from Barbados, where she was born in 1913, and her father, a loving white man, died when she was a young child. Her widowed mother was partly crippled and in despair bravely insisted her daughter emigrate to St Louis with family friends. Her foster family were free-thinking and attracted by the magnetic pull of Harlem, where they relocated

Jacob Lawrence

in 1926. She was immediately inspired by the creative world around her, dancing and painting as she watched the jazz star Ethel Waters emerge from the building they shared into a waiting limousine each night.

Despite their diverse experiences of the same neighbourhood, Lawrence and Knight shared a natural gift for art and, after each of their educations was cut short by the Depression, they finally found themselves in the same room. Although they both enjoyed the support of Augusta Savage, a highly respected professional black woman artist who ran influential workshops that birthed a generation of Harlem talent, they did not encounter each other until Knight began working for Alston. In 1934, Knight was helping Alston with a mural at Harlem Hospital when she fell in love with his mentee, who was four years her junior. She described Lawrence as having beautiful skin and long eyelashes to die for. They married in 1941 and Knight dedicated herself to furthering her husband's career.

In the years between meeting and marrying Knight, Lawrence established himself as a key voice in the Harlem Renaissance with his seminal *Migration of the Negro* series (1940–41). Still in his early 20s, Lawrence created an ambitious masterpiece of American history painting. The scale is staggering, as was the speed with which he created the 60-panel work: with Knight's assistance, it was completed in eight months in a building with no running water or electricity. The characters in his fable-like scenes are part naive, part stylised but not unhuman, and in his economical style he demonstrates both the hope and the despair of a sea of African American migrants who chose to vote with their feet. The epic series offers an unsentimental presentation of events and is a dignified monument to the mass migration that reshaped the country. It was also Lawrence's entry into the art world, after the Museum of Modern Art bought many of the panels and he became the first African American artist to have a solo show there.

The artists enjoyed a year-long honeymoon after the series was completed. Knight continued to paint the portraits and still-lifes that had preoccupied her since childhood. Her style was looser and her subjects drawn from her own world rather than from history. She painted spontaneously, capturing many female subjects she was intimately acquainted with in the relaxed environments of their homes. She was entirely content in her practice, despite her continued lack of recognition alongside an increasingly famous husband. She recognised the dearth of support for women artists: *'The problem is not unique to the black woman artist . . . But I think it's more intensified.'* Thankfully, her passion was not diminished, because in recent decades a new spotlight has shone on her practice and her oeuvre is a treasure trove of paintings and sculpture, presenting a completely personal yet robust account of her twentieth-century experience.

The couple enjoyed Lawrence's uniquely privileged status in the art world and in 1946 accepted the prestigious invitation from Bauhaus legend Josef Albers to teach at Black Mountain College in North Carolina. Segregation laws meant Albers had to book an entire train compartment for the pair, and when they arrived on campus they dared not leave the grounds. However,

once there, the experience was formative for both artists. Although Lawrence was a figurative painter, the hard-core abstractionist Albers admired his deconstructed form and honesty to colours. Knight was not engaged as an official teacher, but the school was very informal and she led dance classes and impressed Albers by fashioning costumes from curtains. They were a charismatic, attractive, free-spirited couple, perfectly suited to the bohemian nature of the college.

Lawrence went on to become a significant art teacher after learning from Albers, one of the greatest art teachers of the century. His museum-level career was a beacon for young African American artists in his wake. Knight continued to paint alongside her husband as they moved from New York to Nigeria and then Seattle. Eventually, in the 1970s, the art world finally caught up and Knight secured gallery representation; museum acquisitions followed steadily over the last decades of her life. Her husband died in 2000, but she lived on to see a major museum retrospective in 2003, and died two years later. Although each took the African American experience to be their subject matter – Lawrence from an external historic perspective and Knight from a personal viewpoint – neither sentimentalised it in their work, which gives it valuable agency today. They remain a vital source of influence for a generation of African American artists starting their careers nearly a century later. Without Lawrence, there would be no Kehinde Wiley or Hank Willis Thomas, and Knight's personal vision of the black female psyche underpins work made by Mickalene Thomas and Kara Walker today.

Lawrence was a key voice in the Harlem Renaissance, exemplified by his epic series depicting African American migrants.

Jacob Lawrence

Kay Sage

&

Yves Tanguy

1938–1955

Kay Sage and Yves Tanguy are often misunderstood as incompatible warring lovers, and the balance of power and talent in their artistic pursuits is misconstrued. We might imagine theirs was a marriage lacking in love, for they often fought in public. Tanguy pushed and verbally assaulted Sage and she frequently intervened as Tanguy tried to physically butt heads with male guests at parties. We might also be led to believe that Sage was an amateur artist, as Tanguy is so frequently regarded as the original artistic voice. This theory is still supported by the relative value at auction of each artist's work.

However, even a cursory reappraisal demonstrates that Sage's work has its own distinct authority, was well received and, in her lifetime, may have been more inspirational to Tanguy than their contemporaries realised. And as for their love, it was clearly deep and complex in private. After Tanguy died suddenly, Sage wrote in her poignant suicide note:

'The first painting by Yves that I saw, before I knew him, was called "I'm Waiting for You".

I've come. Now he's waiting for me again – I'm on my way.'

Her tragically romantic departure from this world to be reunited with her lover may seem apt for a woman whose life was unconventional from the start. She was born into a wealthy family in 1898, and her mother left her husband and Sage's father soon after her birth and took the young girl as a companion as she travelled throughout Europe. Sage learnt both French and Italian colloquially from the servants who attended to her as a wealthy itinerant nomad. She studied art in Rome and met an Italian nobleman, Prince Ranieri di San Faustino, whom she married in 1925. She anticipated a happy 'fine' life as a princess with a man whom she described as *'me in another form'*. Eventually for Sage, this refined world became a *'stagnant swamp',* and she left desperate to do something constructive and creative.

At the point of rejecting her life in Rome, she was also reborn as an artist, throwing away her formal training and recommitting herself to a new progressive visual language of her own making. In 1938, having relocated to Paris, she fell under the spell of surrealism after seeing the International Surrealist Exhibition, where she was particularly energised by the work of Giorgio de

Yves Tanguy's I Am Waiting for You *was immortalised by Kay Sage's suicide note.*

Chirico. Perhaps the Italian artist's unique point of departure from traditional Italian painting showed Sage, herself well versed in the language of Italian art, a way to break free. She soon began painting as and identifying herself as a surrealist. Crucially, it was at this exhibition that she first saw Tanguy's work, in fact the very painting immortalised by her suicide note, *I Am Waiting for You* (1934).

Tanguy also encountered Sage's paintings before he met her in person. He recalled seeing her work at a salon in Paris: *'Kay Sage – man or woman? I didn't know. I just knew the paintings were very good.'* Tanguy, already an established artist, was a close friend of the surrealist poet and charismatic leader of the group, André Breton. Tanguy was so taken with Sage that he ended his passionate affair with the powerful and highly influential art dealer and collector Peggy Guggenheim. Sage was financially generous to Tanguy and his bohemian set, but Breton and his circle did not warm to Tanguy's new lover, whom they regarded as a haughty princess, and refused to welcome her as a surrealist. Whether resigned or unaffected, Sage daringly continued

to describe herself as a surrealist, regardless of her lack of 'official' acceptance.

Tanguy, however, was very much a firm favourite among the surrealists and those that followed and supported their work. He was an eccentric soul, eating spiders as a party trick and wearing his hair in a self-consciously Mohawk-like fashion, which we would now describe as punk. A self-taught artist, he made a huge contribution to surrealism by devising mindscapes, which endeavoured to represent the terrain of unconscious thought. Like the other artists associated with the movement, he was fascinated by dreams, memory and the power of repressed desires. His works are instantly recognisable through the use of fluid, desolate landscapes, hovering between reality and dreams, with rock-like forms that engage the viewer but deliver no recognisable subject. Salvador Dalí later admitted to being hugely influenced by Tanguy's quasi-hallucinatory visual language.

Sage created much of her mature work after the couple settled in Connecticut, having departed for the United States soon after the

Second World War broke out. They married in 1940, and both had well-received solo shows in New York the same year. They cultivated an artistic circle as the surrealist 'It' couple and shared a converted barn studio, crucially with a separate working space for each. Sage told *Time* magazine in 1950: *'We both dislike terribly the idea of being a team of painters.'*

A cursory look at her work reveals similar paint handling and the pursuit of constructing a surreal dreamscape. However, Sage's work is dominated by the continued use of architectural forms such as towers, phallic structures, walls, lattice-like forms and beams. Her paintings usually create a distinct sense of foreboding, an air of abandonment. Tanguy's work, by contrast, features organic, soft and fundamentally abstract and empty landscapes, however misleadingly 'real' they may first appear.

Throughout their 15-year marriage, they were inseparable and there seems to have been a spirit of competitiveness between them. Certainly, there was a real interchange of ideas, although it may not always have been conscious. They exhibited together only once, at Wadsworth Atheneum in Hartford, Connecticut, in 1954.

Sage received critical success: winning prizes, selling to major museums and exhibiting regularly, including in the historic exhibition '31 Women' organised by Peggy Guggenheim (clearly art came before thwarted love for the dealer). However, whether fair or not, Sage was always in Tanguy's shadow, both in his lifetime and after his death in 1955. Once alone, she painted less frequently due to depression and failing eyesight caused by cataracts. She set about preserving Tanguy's legacy by ordering his archive and completing a major catalogue of his work. She attempted suicide by overdose in 1959, a few weeks after completing these tasks, but survived. For several years, she regained stability and pursued her own artistic endeavours, making sculpture and enjoying a major retrospective in 1960. Three years later, soon after Christmas, Sage shot herself in the heart. Her ashes were combined with Tanguy's, and the two surrealists were set free on the rocky Brittany coast that so resembled their paintings.

Yves Tanguy

Nancy Holt

&

Robert Smithson

1962–1973

There was a permanent third wheel in the marriage of Robert Smithson and Nancy Holt, and it was the Great American West. The three were a close triumvirate; Holt recalled that when she first journeyed out to the vast horizons with Smithson, she was so thrilled she could not bear to sleep for four days. She realised: *'I had this Western space that had been within me. That was my inner reality. I was experiencing it on the outside, simultaneously with my spaciousness within. I felt at one.'* In the security of their young creatively dynamic marriage, Smithson and Holt found a new visual language. They each went on to make artwork that entered the canon of art history and gave birth to an entirely new attitude to the practice of making and showing art.

The art world they inhabited was 1960s New York, exemplified by the Chelsea Hotel and Andy Warhol's Factory. The era still shone with the stardust of the pop artists and abstract expressionists. However, Smithson and Holt found themselves perfectly situated in the stirrings of a stimulating moment of genesis when the next generation was challenging what had come before. The timing was perfect for an alternative way of thinking. The artistic climate was increasingly a clinical riposte to the commercial and loud movement before; minimalism and conceptualism were the new directions.

In addition to arriving in the art world at this fertile moment of re-imagining, the artists had been recipients of good fortune once before. Years earlier, Holt and Smithson attended the same high school and were coincidentally reintroduced by a mutual friend while Holt was visiting New York as a student in 1960 to meet artists and see exhibitions. This marked the start of an intense exchange of ideas between the couple.

Holt's outlook was a self-fashioned hybrid that fused art and science. Unusually, while studying biology at Massachusetts Institute of Technology, Holt also attended art classes and lectures. She was years ahead of any mainstream educational coming-together of these disciplines. Smithson was already working as an artist in New York by the time he reconnected with Holt, someone whom he felt shared his outsider's viewpoint. In 1962, after travelling around Europe with friends, Holt lost both her parents within a short space of time. She was still processing this grief, reading psychoanalytical texts and working out who she wanted to be as an artist, when she moved into Smithson's modest apartment in Greenwich Village in 1962. They married in June 1963. They were a magnetic pair, often hosting impromptu, late-night gatherings of artists in their home.

Both Smithson and Holt believed in taking art out of the 'white cube' of the gallery. Instead of trying to capture the complexity and profundity of the natural world in a canvas or a bronze, the artists and other exponents of land or earth art instead used the land itself. They insisted, by the very location and medium they chose, that the land be re-experienced as art. Holt was slow to manifest her conversations about land art, taking her time to find her feet in this world of new ideas. Smithson, by contrast, acted fast, with authority and epic scale.

Nancy Holt

Smithson not only coined the term 'land art' but also created the most famous example of the new movement, *Spiral Jetty* (1970). This seminal work is a serpent-like coil of more than 6,500 tons of rocks that extends across the Great Salt Lake in Utah. Measuring 1,500 feet (460 m) long and 15 feet (4.6 m) wide, this was art on an unprecedented scale. Smithson's staggering intervention in the pink salt plains demonstrates both the magnitude and fragility of nature. Instead of aiming for a precious, fixed artwork with the anticipation of immortality, his already prehistoric-looking rock formation immediately showed signs of deterioration.

Smithson is recognised as one of the most enigmatic artists of this period. With *Spiral Jetty,* he created an instant masterpiece in the middle of nowhere, which then vanished for decades due to the rising water levels of the lake. Furthermore, his fate as an artist-hero was sealed when he died soon after making *Spiral Jetty* in an airplane crash while searching for new sites for his next piece. He was just 35 years old. Holt and Smithson should have grown old together, witnessing the slow metamorphosis of their art in nature and their direct significance to the growing appeal of what is today's most important medium, experiential art. Instead, they were married for only ten years.

Holt's masterpiece, *Sun Tunnels,* was created between 1973 and 1976 in the period after her husband's death. The artwork is formed of modest means: industrial concrete tunnels aligned in pairs according to the axis of the winter and summer solstices. Circular holes of differing diameters are drilled into the concrete in the formation of the constellations of Capricorn, Columba, Draco and Perseus. The result is to bring the sky down to earth, with a constant pattern of light playing on the inside of the tunnels. Holt both frames and re-imagines the landscape, the tunnels becoming a stage for the theatre of the sun. Her primary concern was to demonstrate the cyclical nature of time and integrate her art by framing, not competing with, the landscape.

Land art was undoubtedly a macho pursuit. Between the main figures (who were all men and received grants and private funding for their work), there almost seemed to be a competition to surpass the previous notions of scale, physical feats and elements of risk involved in creating gigantic interventions. Holt, on the other hand, took an alternative approach, one that left hardly any physical trace. She did not so much *make* land art but find simple, light ways of inviting the audience to look again at what nature and the universe had already created. From the very beginning, she demonstrated a consideration of an artist's responsibility to protect rather than alter the natural world, which put her years ahead of some of her peers who were less environmentally sound.

Holt enjoyed a long, distinguished career, outliving Smithson by four decades. She never remarried; she stated she was content enough with her artistic practice and securing the preservation and fame of Smithson's archive. In recent years, she has been the subject of a worthy refocus of attention. Long overshadowed by the artist who disappeared along with his masterpiece, her work is now literally and metaphorically basking in the light of the sun.

Robert Smithson

Marina Abramović

&

Ulay

1976–1988

At the Venice Biennale in July 1976, a naked couple hurled themselves together, running frontally into one another with their bodies upright like two clapping hands. The figures were young and slim, a man and a woman with long dark hair and long limbs. The only sound was footsteps gaining momentum and then the hollow ringing of bone and flesh slapping into another body with increasing violence. Repeating the action, eventually the male figure knocked the female to the floor. Expressionless, he silently turned around as she picked herself up, and each began the run-up for their choreographed assault again. Almost an hour earlier, the pair had begun by simply walking towards one another, limbs gently brushing limbs, like Adam and Eve strolling in paradise. The hour-long piece is called *Relation in Space* and is a historic work by the greatest duo of performance art, Marina Abramović and Ulay.

Perhaps more than any other artistic duo, Abramović and Ulay sacrificed themselves as a couple to the temple of art history, creating intensively demanding work that relied on total commitment to one another emotionally, physically and intellectually. Many of their joint performances are hard to watch. In *AAA-AAA* (1978), a grainy black and white video, the pair stand with their faces an inch apart, the camera trained on close-up while the two profiles scream full frontally at the other in unison. Their voices go hoarse, the veins in their necks pop and their eyes bulge. The effect on viewers is devastating: the guttural violence an attack on their nervous systems. The unbreakable mutual trust, absurd dedication and dark commitment to truly explore all facets of human relationships are markers of a unique 12 years as lovers and partners.

The couple were each building their independent artistic careers when they met in 1976, when Abramović was invited to perform in Amsterdam. Their instant attraction was sealed when they discovered that they shared the same birthday, 30 November, and had each ripped that dreaded page from their diaries. Abramović was born in Belgrade, then capital of Yugoslavia, in 1946 to comrade parents who fought on the front lines and had been rewarded with high-ranking positions in the new regime. They were thus a curious mix of spartan communist rebels turned bourgeois couple, who endured a volatile marriage. As a result, their daughter was strictly controlled and denied affection, but was showered with every cultural and educational opportunity. Ulay, who was born three years earlier than Abramović, as Frank Uwe Laysiepen, was by contrast an entirely self-taught and self-made nomad, without any concerns for the canon of art history. Born to a Nazi soldier in a bomb shelter, Ulay struggled with his 'Germanness' as a young adult and relocated to Amsterdam in 1971; at the same time, he adopted his pseudonym. He lived in a state of gender fluidity, presenting as half-man, half-woman split down the middle of his body: one half of his hair was long and the other side of his head sported a moustache. Abramović was transfixed by his progressive values and otherness, and their self-constructed myth was born the very night they met. They spent ten days in bed, and once she returned home Abramović recalled: *'I get so lovesick I cannot move or talk.'*

They each fiercely guarded the quality of fairness and agreed to meet again in Prague, as it was midway between Belgrade and Amsterdam. Knowing that they shared a profound and all-

encompassing love, they abandoned their old lives, which included a spouse for Abramović, and created a new unit that centred on the pair, their dog and their unconventional home: a Citroën van. The lovers did not separate again for 12 years as they travelled like nomads together, creating and performing their collaborative work. Life in the van was paradoxical: it was a claustrophobic, spartan home, but it was also limitless and allowed them to live with great freedom. In the winter, they curled up with the dog to keep warm and Ulay recalled: *'It might have been the most happy time in our lives.'* Given that their work was so progressive in its explorations into the dynamics of a couple, it is interesting that in their domestic lives they conformed to separate spheres of gender activity: Ulay took care of finances and practicalities and Abramović used housekeeping money to cook and clean.

Their performances, which took the possible conflicts of a relationship to an extreme, were the opposite of how the pair lived together. When cracks did start to emerge in their partnership, they went unnoticed for some time and they stemmed directly from their practice. In *Nightsea Crossing* (1981–87), the artists sat across from each other staring motionless for seven hours a day; they had become a living breathing painting. Ulay could not match Abramović's staying power; his incredibly high metabolism meant he could not keep weight on his body, which would tire and ache quickly sitting with no cushion of flesh. When he stood up, he was at the end of his staying power; he was defeated, but Abramović remained in the performance. Tensions also arose as a result of the success of the partnership. Ulay was a natural anarchist and struggled with their new-found status: *'When anarchist becomes institution it's ridiculous.'*

They endured an unhappy final three years together. Just as they choreographed their coming-together with a poetic equality, meeting

in Prague, they also stage-managed their eventual split. Again, they met in the middle, this time on the Great Wall of China. In 1988, Abramović began her 1,553-mile (2,500-km) walk from the Yellow Sea and Ulay began his in the Gobi Desert. After an arduous three months of spiritual hiking alone, they came together in order to be able to separate, creating what must be the most personal, poignant, devastatingly romantic pieces of performance art in history. *The Lovers: the Great Wall Walk* was a dramatic end to a unique partnership, and for Abramović, who hated to admit defeat of any kind, it was impossible to stay in touch with Ulay, who believed that *'love turns to hate'.*

Almost 20 years of silence passed, and Abramović went on to become one of the world's most respected contemporary artists, enjoying an international fame and an unusual level of mainstream recognition. In 2010, at her Museum of Modern Art retrospective in New York,

she refashioned *Nightsea Crossing,* the seated endurance piece she had created with Ulay. *The Artist Is Present* saw Abramović sit immobile in the gallery every day during opening hours – totalling over 700 hours across the duration of the exhibition – inviting the public to sit across from her and share a silent, spiritual connection. There was no physical contact, that is until Ulay arrived. He re-entered the frame by way of a re-imagined version of their earlier performance. Abramović, sharing tears with Ulay, broke her position and reached out to take his hand. The footage of this moment went viral. Performance art may still be a difficult medium for some to digest, but the ending of a 20-year emotional exile and the reconciliation between former lovers are universal and powerful themes. The fusion of art and life could not be more pronounced, and although they remained separate Abramović tenderly acknowledges the *'really beautiful work we left behind and this is what matters'.*

Gilbert

&

George

1967–present

The art and life of Gilbert & George, who function as one artist, is a confounding paradox. The work they produce is controversial and provocative, their large photomontages brashly tackle difficult or taboo subjects and they have not been shy about their own naked bodies, semen or faecal matter. Their art is unrelenting in its dizzying, impenitent undermining of religion, power, sexual norms, politics and British identity.

Yet, the couple have cultivated a persona and comportment entirely at odds with the anarchic and confrontational nature of their art. They permanently dress like old uncles in tweed suits, they shun the spotlight of the art world and their daily life is so driven by routine that it is almost ascetic in its privations. As a gay couple, they were pioneers of homosexual imagery, which had been absent from art history since ancient times. However, they express profoundly conservative anti-liberal sentiments, for example celebrating fascism, and make statements that are frequently at odds with the queer art community.

The combination of deeply engrained anachronistic attitudes – they have not been to the cinema since 1979 and do not have many nice things to say about other contemporary artists – and foul-mouthed, lurid artwork made by two men who like to make smutty jokes, but are also extremely polite and old fashioned, is disconcerting. One cannot help but wonder if their personas were initially cultivated as part of their idea that they are living works of art, but after a while they stuck: an artistic self-fulfilling prophecy.

If this is true, then the real Gilbert Prousch and George Passmore were last seen at Central Saint Martin's art school in 1967. It was love at first sight for Gilbert, who hailed from the Dolomite region in Italy. He said: *'I followed like a dog',* in reference to Devon-raised George. Both men came from impoverished backgrounds, growing up without electricity, hot water and decent food. By the time they graduated from their advanced sculpture course, they had become what could be considered an advanced form of sculpture themselves, nominating their very bodies *in situ* together as 'living sculptures'. Originally they photographed themselves holding sculptures – purposefully concealing which artist made each work – and then they simply removed the actual sculptures. *'It was our biggest invention. We had made ourselves the artwork.'* This was partly motivated by poverty – they lacked funds to make anything – but also by a position of unorthodoxy, which was deeply engrained in Gilbert & George since the moment they came together.

After finding gallery representation and starting to sell work, for sums they believed to be preposterous and yet gleefully spent on gin and misbehaving,

they bought a run-down Georgian house in Spitalfields, East London, which they lovingly restored over several years. Here, they cultivated a small world for themselves in a now gentrified area of which they are considered early pioneers. There is no kitchen, as they believe cooking to be counter-productive. They run their day to a strictly timed regime, eating breakfast and lunch at the same greasy spoon cafe each day and dinner in the same Turkish restaurant each night, consuming the same meal for about three months before switching. They pride themselves on being well known in the area: photographed by tourists, friends with the postman and stopped on the street by working-class men who tell them they love their work. Conversely, they like to think of themselves as unloved and disrespected by the art world, instigating an argument with the Tate because their 2007 retrospective was planned at the Tate Britain, home of British artists, and they felt they belonged, as an Italian and a Brit, in the 'less old-fashioned' Tate Modern. To pick a public fight with the most respected exhibitor of contemporary art in Britain was unthinkable to many, and yet Gilbert & George take evident pride and delight in being aggressively unconventional and outspoken.

Their entire approach to making art in the late 1960s and 1970s seems to have been cultivated to run counter to as many art world trends as possible. They used colour when the world of fine art photography was strictly a moody black and white. They placed themselves in the work, appearing as a double self-portrait alongside photographs of everyday London landscapes and objects. They were literal and figurative when minimalism reigned. They expressed opinion and demanded a response from the viewer, almost goading them, in an age when personal expression was taboo in art. They used smutty words, took a knowingly childish approach and revelled in obscenity, all tactics that were normalised in the later YBA, or Young British Artists, era but were entirely new in the 1970s. They met the year that homosexuality was decriminalised in Britain, and it is tempting to assume that their constant deviation from conventions stemmed from being outsiders. But the pair refuse to be drawn on 'queerness'; they are disdainful of terms like 'gay sex' because to them it is just sex. When asked if they are spokesmen for gay people, they state: *'[We] are just the opposite.'* When asked if they have anything so normal as a lover's tiff, they respond obliquely: *'Ah, the great heterosexual question!'*

In 2008, they formed a civil partnership, a slight crack in the facade of disdaining authority and convention but insisted it was only to protect their financial interests. The world in which they live is a weird combination of being entirely open – we have seen them naked; they have never hidden their sexuality or opinions – and defiantly closed to outsiders. They wish us to believe that what they show is all there is. Like the stained glass-looking photomontages, everything sits on a surface that cannot be broken to reveal any depth. Even when confronting the image of one of the duo dying, they have a quick riposte: *'People always ask us what we will do if one of us gets run over. We say: "Fear not! We always cross the road together."'* They have rigorously performed as Gilbert & George 365 days a year for over 50 years.

George

Joseph Cornell

&

Yayoi Kusama

1962–1972

In New York from the early 1960s to the early 1970s, amid a seismic social sexual awakening, existed possibly the most innocent of all romantic entanglements between two artists in this book. The US artist Joseph Cornell was in his late 50s and still living at home with his mother in Queens when he met Yayoi Kusama, a Japanese artist 26 years his junior. He fell in love with her at first sight; she was wearing her finest kimono and wore her dark waist-length hair loose. Kusama was not as entranced with Cornell's dishevelled appearance: he looked older than his years and his clothes were so shabby that he was often mistaken for a hobo. She did, however, fall quickly in love with his work and the innocence of his obvious affection.

Both Cornell and Kusama are considered outsider artists to some extent. Cornell came to art late, at the age of 30, with no formal education. He dreaded the simplest of social interactions, let alone the schmoosing of the art world, and was the victim of an unfortunate domestic situation: he never moved out of the family home that he shared with his disabled younger brother and intensely overbearing mother. Kusama has lived, by choice, in a hospital for the mentally ill since 1977 in Tokyo, and like Cornell is also uninterested in society at large or indulging the vanities of the art world. Neither artist cared for money and both were driven to make their artwork by something far deeper and more compulsive than fame and riches. Despite this apparent resistance to the commercial and social aspects of the world, today Kusama and Cornell are two of the most respected and beloved names in modern art. Cornell, who died in 1972, is a cult figure of great significance. He is credited with a clear and enduring influence upon artists of his time, such as Jasper Johns, Robert Rauschenberg and Andy Warhol, as well as

Joseph Cornell

countless living artists working today. In the first decades of this century, Kusama has cemented her position as one of the world's most popular and celebrated living artists.

Kusama and Cornell each achieved this without pandering to the changing tastes of the art world. They devoted themselves to a resolutely singular artistic practice for their entire careers. Kusama's signature polka dots cover not only the surfaces of her canvases in 'infinity nets', but also the contents and walls of entire rooms. Instantly recognisable too are her pumpkin sculptures, a subject as emphatically owned by Kusama as sunflowers are by Vincent van Gogh. Cornell shared a similar preoccupation with one striking visual language for which he found endless variants. For nearly four decades, he carefully and thoughtfully assembled found objects into shadow boxes. His small assemblages took the mundane and discarded and refashioned them into small private, surrealist chambers of his imagination.

It is tempting to emphasise the reclusive nature and qualities of 'otherness' that characterise each artist. Cornell had a debilitating mother complex and Kusama has endured hallucinations and mental psychosis since childhood, which have been marshalled into her art. We might do this because the legend of the artist unappreciated in their lifetime still holds a romantic appeal. But this reading is wide of the mark for both artists. Kusama arrived in New York in 1957 and, despite poverty and initial isolation, became an art world celebrity from the mid-1960s: her exhibitions were international and widely reviewed. Cornell did not travel, except through the wanderlust ever present in his boxes, but his artwork was known through extensive exhibitions. He may have been reclusive, but the stream of A-list fans he received at his home is extremely impressive, including the artists Andy Warhol and Marcel Duchamp and the Hollywood star Tony Curtis.

The demand for Cornell's work was high. He hated parting with it despite needing the financial support, and hungry dealers would go to great lengths to butter him up. This is why Gertrude Stein (no relation to the Paris-based patron earlier in the century) took a young Kusama to meet Cornell at his home in 1962. He had expressed to Stein an interest in learning to draw and needed a model. Stein instructed Kusama to wear her best clothes and they headed to Queens. Kusama reports that the same day, after a victorious Stein had departed after buying some boxes, they each drew each other in the nude. It is very likely, therefore, that Kusama was the first woman Cornell, already in his 50s, saw naked. She was certainly the first woman he kissed.

Kusama devotes three chapters of her autobiography to the man who *'struck me as frightfully old'* and was *'legendary'* in the Manhattan art scene. He instantly began to send her poems and love letters, sometimes as many as a dozen a day. She recounts his *'telephone blitzes',* when he would spend five to six hours a day on the phone with her and think nothing of hanging on the line while she cooked, ran errands or worked. In her account, he sounds like an infatuated teenager in the throes of puppy love, asking: *'Yayoi, what do you think of me? Do you like me?'* She describes how the situation eventually became intolerable as he began to affect her ability to work, not

Yayoi Kusama's use of polka dots and pumpkins have become synonymous with her work, as did Joseph Cornell's assemblages of mundane trinkets.

Yayoi Kusama

to mention tying up her phone line, a precious connection to dealers and curators. But her anger softened: *'There was something powerfully appealing about him. And his art was simply fantastic.'* For Cornell, Kusama represented a sacred sexual territory, one that, as a virgin still tied to his mother's apron strings, he was becoming increasingly obsessed with as he approached old age. He described in his journal that his time kissing and touching her body was *'erotique'* – always relying on French words to communicate what were for him major milestones of passion. To Kusama, Cornell was a genius and an unthreatening male figure, for despite her reputation as an artist making sexually charged happenings, she too was a virgin terrified of sex.

Both Kusama and Cornell had endured stressful childhoods. Kusama was a victim of her mother's anger and mistrust of her philandering father, and was sent as a young girl to spy and report back. Everything untoward that she witnessed made her not only the messenger but also at fault to her unstable mother. At the age of ten, she began to experience terrifying hallucinogenic episodes. By the time he was 13, Cornell's innocence was also shattered: his father had died, his younger brother suffered from cerebral palsy and he became both primary care giver and bread winner. He was intensely religious his entire life, which further heightened his repressed sexuality. His mother, eternally disappointed in her eccentric eldest son, expected complete loyalty from Cornell and made no attempt to disguise her hatred of Kusama. After she caught the pair kissing in the garden, she poured a bucket of water over them as if they were wayward cats. Completely soaked and humiliated, Kusama listened as Cornell's mother scolded him: *'How many times do I have to tell you Joseph? You mustn't touch women. Women are filthy.'* Understandably, Kusama was increasingly keen to sever ties.

In 1972, Cornell began his telephone assault again, desperate to see Kusama while recovering from a prostate operation. Unimpressed, she remarked that Salvador Dalí always sent a Rolls Royce for her when he expected a visit. Shortly afterwards, one of Cornell's loyal collectors arrived to pick up Kusama in a Mercedes. This visit was the last time they saw each other. Cornell cried tears of happiness and they again sketched each other nude. Afterwards, Kusama recalls his final attempt to jump-start his sexual awakening, fiercely kissing her and pulling *'his thing out of his trousers . . . it was indifferent to my touch and devoid of any sexual appeal whatsoever'*. Cornell died incurably impotent that same year.

Four decades after his passing, Kusama wrote: *'There has never been anyone whose heart was purer.'* For her, completely disinterested in the physical act of sex but fanatical about art making, the greater tragedy was not that they never consummated their strange but important relationship, but that Cornell went to the grave with a work unmade. He wanted to create a 'Yayoi nude box' and she failed to send him the photographs he repeatedly requested. Fashioned with his own hands, like every mini adventure in box form he had made before, this would have been a poignant stage set, where Cornell would finally have been free to fully throw off his sexless old body and escape to ecstasy with Kusama.

Yayoi Kusama

Carroll Dunham

&

Laurie Simmons

1977–present

To outsiders, the idea of two independent artists existing within one marriage is a peculiar and confounding notion. This is presumably born of the popular belief in society that the artist possesses a different grasp of the world and is sensitive with a streak of egotism. The particular magic at play seems delicate: the artist hunts around for inspiration and dedicates themselves to a universe of their conjuring. Although they wrote the rules, most cannot help but ask for validation, and the idea that two adults might do this within one household seems perilous. The New York artists Carroll Dunham and Laurie Simmons have been together for four decades and always maintained that they were safe from whatever perceived threat there might be for each of their practices within the marriage. As they see it, this is mainly because Simmons works with photography and film and Dunham is a painter.

Their separate spheres of activity and the specificities of their media act as a protective cloak. Simmons' playground is populated by cameras, props, studio lights, film, printing and editing, whereas Dunham's terrain is pencil, paint, paper, canvas, erasing and repainting. Simmons channels the world through an intermediary lens and Dunham directly through his brush. Marking out their own artistic territory is supposed to be a way to guard their creative integrity, preventing competition and comparison.

Yet, Dunham and Simmons have discovered as the years have passed that there, somewhere in their artistic solitude, is the ghost of the other. A series of paintings that Dunham made is in hindsight indebted to Simmons' earlier work, and vice versa – not as a form of parody or homage, but in an entirely unexplained, blind fashion. It takes the completion, exhibition and discussion of the series for the penny to drop; a buried fragment of the other's work has been dislodged and is now on display in their own. The entwined threads of their art are all the more fascinating when one considers how different their outlook and practices are.

Simmons always knew she was going to be an artist, introducing herself as such while still a young child. Dunham, on the other hand, did not even know it was a viable way to live one's life and did not identify as an artist until he was in his 20s. Both emerged in New York in the late 1970s, in the comedown from Andy Warhol and the Chelsea Hotel, an era when painting really was dead this time and women artists had advanced, in so far as everyone now talked about them being overlooked. They shared an impulse to carve out their own practice in defiance of what everyone else was doing. Painting was unfashionable, perceived to be a dead-end street, and conceptualism, minimalism, installation and performance reigned supreme as the new modes of expression. Dunham would crawl into the discarded wreckage of painting, naturally finding his feet as a great lover of the weighty canvases of art history. Simmons would reject painting not because it was dead but because it had been the domain of the male artist for so long. Rather than work in a field that excluded women, she and a generation of young artists, such as Cindy Sherman, turned to photography, a fine art medium too young to be tarred by gender politics.

The artists were part of the same circle, attending exhibitions and performances in an art world so small that they encountered their heroes at drinks. When Simmons met Dunham in 1977, he told her he liked her work and she took the compliment only half seriously, *'Oh my God, he's a painter'*, as if he were an embodiment of her adversaries. But far from being static and reactionary, Dunham dedicated himself to painting in a bewildering array of approaches, moving between abstraction and figuration in a way that disregards the usual artistic allegiance to one or the other. He is unapologetic about his dazzling range of work – from abstracted forms playing with the wood on which they are painted to cartoon-like creations and uncanny, bold experiments with both the male and female nude – *' . . . all these subjects are really just things that let you make paintings'*. Dunham remembers his friends trying to move him away from his early adventure into painting in an effort to help this intellectual art lover fit into their progressive way of working.

Simmons was also self-conscious about not fitting in when she first began exhibiting the dolls series she had been working on since discovering a vintage doll's house in 1972. *'I was looking at this really tough, hard-ass conceptual work and here I was taking pictures of dolls and doll's house interiors.'* The subject was potent for her, on a subliminal level acting as a metaphor for the middle-class Jewish community she had grown up in, which she knew to be beautiful on the surface, but concealing all darker sides of human life. She left for art school as soon as she could, and realised many decades later that the shiny surface and repressed narratives she instinctively felt in her childhood are there in all her work. Her meticulously staged photographs show miniaturised perfect homes, complete with furniture, wallpaper and kitchen utensils, beautifully lit like a Hollywood set. Originally, the work was black and white but developed into colour and began to include female dolls. Later, she used sex dolls and ventriloquist dummies in a similar fashion, carefully staging her avatars of societal expectations from behind an invisible curtain.

The two artists occupy very different spaces in the art world and maintain strictly independent studio space in both their Manhattan apartment

Laurie Simmons' powerful dolls series acted as a metaphor for the mundane middle-class experience, whilst Carroll Dunham's dazzling range of work includes bold experiments with both the male and female nude.

and Connecticut home. They have two children together, one of whom has overshadowed the original oddity of them being two married artists by becoming a famed writer, actor, film maker and voice of intellectual millennials. They fought hard to not overshadow one another and the irony is that to most people they are now the 'parents of Lena Dunham'. As the decades have passed, life has inevitably begun to bleed into art. Simmons played a version of herself in Lena Dunham's breakthrough film *Tiny Furniture* (2010) and conversely both her daughters appeared in her 2016 film, *My Art* (2016), as well as a host of art world cameos and re-imaginings of art world characters. Simmons is dismissive of the *'idea that the air is rarefied because of what we all do. We are arguing, loading the dishwasher, figuring out who's going to pick who up.'*

In attempting to carve out their own space artistically, they were also preserving an arena for real life: marriage, children and the necessities of the shared everyday experience. This is perhaps why their influence on each other creeps up on them as a surprise. The ways in which Simmons and Dunham appear in each other's work are complex, semiotic and subconscious. As Dunham puts it: *'When you live this closely with another artist, for this long, some kind of dialogue is taking place.'* In their work, both Dunham and Simmons explore hidden depths, the location of meaning and what value we give symbols and objects. Just as there can be no single narrative in their postmodern investigations, there is no single artist at work in a vacuum; this marriage is evidence of the invisible entanglement and time warp of all artistic endeavours.

Laurie Simmons

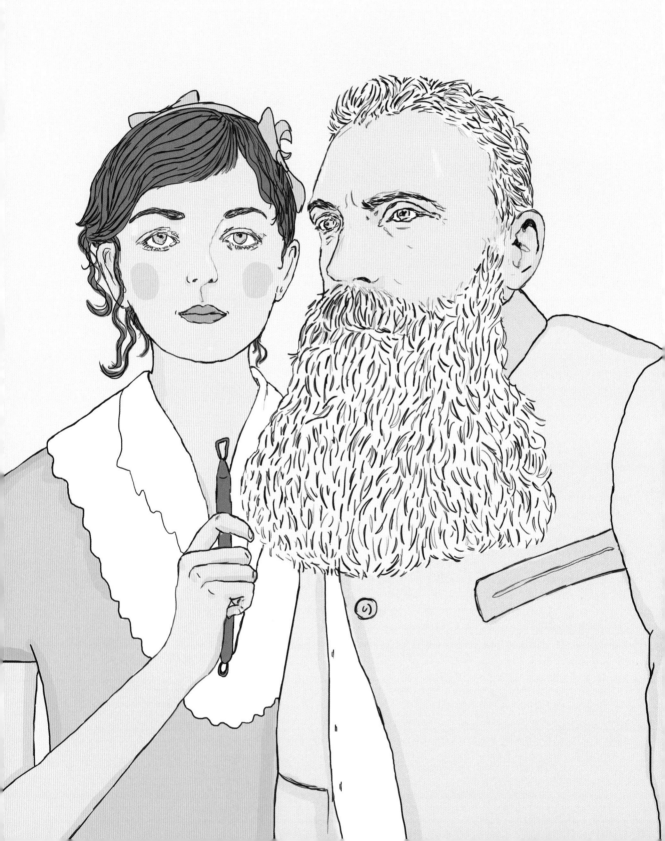

Camille Claudel

&

Auguste Rodin

1882–1893

Camille Claudel was a child prodigy. At the age of just 13, she was digging her own clay to work up into small portrait busts of family members. By her early 20s, she had an impressive mentor, a formal arts education in Paris and a position working as an assistant in the studio of the most successful sculptor of the period. Furthermore, her own work was well considered and exhibited in the prestigious Salon d'Automne and Salon des Indépendants. Astonishingly, this was all achieved in a climate that actively denied women legal rights, let alone access to a creative world happily occupied by men. Hers should be a celebratory story of a vital artistic talent that paved the way for generations to come. Instead, her tale is a tragic romance, the stuff of art historical horror.

At the heart of Claudel's life is the man who proved to be both a blessing and a curse: the lauded sculptor, 24 years her senior, Auguste Rodin. Claudel was 19 years old when she was introduced to Rodin by her mentor Alfred Boucher. Rodin was impressed by the moving realism of her work and his initial reluctance to expand his studio faded away. Claudel was beautiful, strong minded and witty, and soon after she began working with Rodin the two

became romantically involved. At the height of their passion, they worked alongside each other, sculpting erotic, entwined bodies, with figure pressed into figure as if to somehow seal their love in clay.

Unfortunately, Rodin met Claudel too late in life: he already had a long-standing partner, Rose Beuret, with whom he had a son. They had been in a relationship for 20 years, and Beuret had stood by him when he was a penniless artist. He could not push her aside, no matter how strongly he felt for Claudel. So, their relationship was secretive, with Claudel remaining a mistress: a role that required a level of submissiveness that infuriated this independent, brilliant, young woman.

Rodin was one of the most respected and successful artists of his time. Claudel learnt a great deal about sculpting from the master. However, it is apparent that Rodin benefited from Claudel's sensual approach to her own work, which emphasised all that was human and direct. Rodin's iconic work *The Kiss* was created in 1882 and the lesser known but more erotic *Eternal Idol* in 1890–93, two pieces that portray couples locked in passionate embraces that mirror the intensity of his love affair with Claudel. She was not only

his muse and artistic influence, but also worked on many of his most important sculptures, such as *The Gates of Hell* (1880–1917) and *The Burghers of Calais* (1884–95). Studies have revealed that some of Rodin's sculptures were worked by two sets of hands and it is likely that Claudel was working with Rodin as an unnamed collaborator.

Rodin was supportive of Claudel's independent practice as she worked hard to establish her own reputation, exhibiting at the annual Salons and selling work with some modest success, despite the lack of collectors for women's artwork. She was a progressive and intelligent artist, who employed a sensitive lyricism to the weighty subjects of human destiny that preoccupied her. She often worked on classical mythology or other subjects that allowed her to portray states of emotion. *Clotho* (1893) takes as its subject one of the Three Fates, who spun the thread of human life and therefore had the power to decide when a person was born and died. In Claudel's hands, the youngest of the three sisters of Fate was refashioned into an elderly woman, weighed down by passing time and the fate of her powers.

Rodin invited his elite circle of patrons and critics to see Claudel's work, but where they should have recognised an artist who was good enough to have Boucher as a mentor (he also worked with Amedeo Modigliani and Marc Chagall) and employment with Rodin, they saw only her gender and looked for evidence of her master's influence. She was stuck in Rodin's shadow no matter what. Their relationship was tumultuous and Claudel became increasingly frustrated with how little Rodin could offer her personally. In 1886, Rodin tried to appease her by signing a contract that she drew up, which expressly forbade him from marrying anyone else or taking other female studio assistants. A letter of the same period reveals the increasing erratic nature of their love: *'My savage sweetheart,'* it begins, *'there are times, frankly, when I think I'll get over you. But then in a blinding instant I feel your terrible power. Have mercy on me naughty girl.'* After a decade of being together, Claudel forced herself to walk away from the affair.

She worked obsessively, and in the early years of their separation they remained in contact. Her masterpiece, *The Age of Maturity* (1898), is often read as an allegory of her failed relationship with Rodin, with three figures representing the harsh struggle and sad triangle between Claudel, Rodin and Beuret. The situation became increasingly dire for Claudel as her 30s wore on: she had no family support after her mother learnt of her affair. Claudel came to believe that Rodin and 'his gang', as she called them, were sabotaging her career. *The Age of Maturity* was at the core of this belief, as a government commission to cast the work in bronze was mysteriously cancelled. The nature of the sculpture may have embarrassed Rodin, but whether he interfered or not Claudel's other work was problematic. The level of sensuality was too progressive for conservative jury members, especially in the hands of an unmarried woman with no formal studio attachment.

Claudel bitterly descended into poverty and her increasingly serious mental instability and paranoia halted her artistic practice. She brutally destroyed much of her work and lived as a destitute recluse. In 1913, shortly after the death of her father, her brother intervened and had her admitted to a psychiatric hospital, where she remained involuntarily for 30 years. Tragically, her doctors believed her well enough to leave after an initial few years of treatment, but her family would not assume responsibility for her. It is believed that Rodin sent her money over the years but feared a visit would cause another attack. She died alone in the asylum, buried in a common grave in 1943. After the war, her nephew endeavoured to bring Claudel's body to the family tomb, but her remains were impossible to find.

In recent decades, her life story was too tantalising for movies and books to ignore, and now, finally, Claudel's genius as an artist will also be appropriately honoured. In 2017, a national museum was opened in Claudel's hometown; it displays around half of her surviving 90 artworks, providing a home for her important legacy. Although there is no trace of her body, there is finally a serious resting place for her sculpture.

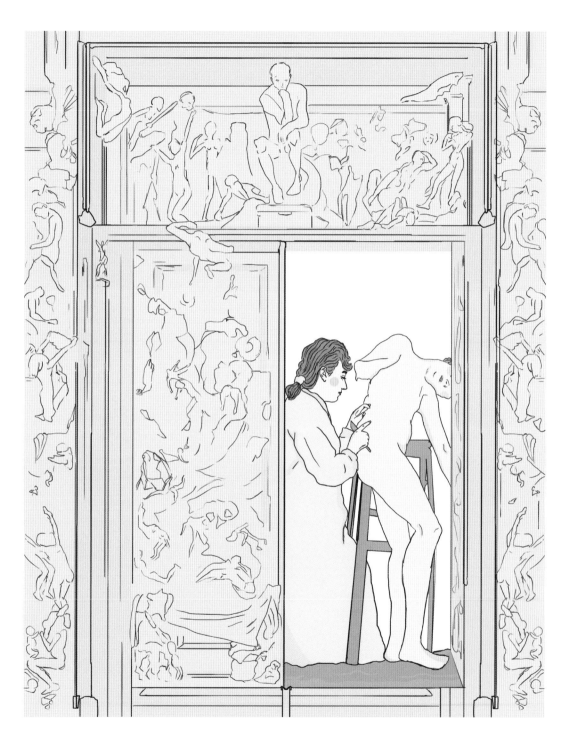

Auguste Rodin's The Gates of Hell *frames Camille Claudel as she works obsessively on her impressive sculptures.*

Auguste Rodin

Maud Hunt Squire

&

Ethel Mars

c.1898–1954

When we picture the bohemian Saturday evening salons hosted by the progressive writer, thinker and art collector Gertrude Stein, we readily conjure up the presence of Henri Matisse or a young Pablo Picasso holding court. But, if it were possible to travel back in time to Paris in around 1907, we would also be lucky enough to encounter two other artists who are poorly recorded by history: Ethel Mars and Maud Hunt Squire. Stein, herself in a relationship with a woman at a time in which homosexuality was deeply taboo in Western society, was a collector not only of art but also of people. She orchestrated a court of artists, poets, writers, philosophers and bohemian souls, in which Mars and Squire fitted beautifully.

In a short poem of 1910, Stein applauds the 'gay' lives of Miss Furr and Miss Skeene, disguising the identities of her friends (Skeene was Squire's nickname). In so doing, she unknowingly made history, as it was the first recorded use in literature of the word 'gay' to describe a same-sex partnership. The coded meaning of the word was not yet in mainstream culture, and Stein safely and playfully celebrated the women who had come to Paris to 'cultivate something'. The poem was later published in *Vanity Fair* in 1922, but it is only in this century that the artists immortalised in the prose are being rediscovered and championed.

Mars and Squire first met at the Art Academy of Cincinnati in the early 1890s and, after completing their studies, made various trips to Europe while working as children's book illustrators in New York. They finally succumbed to the magnetic pull of Paris around 1906, joining a wave of artistic ex-patriots who relished the bohemianism and avant-garde potential of the city of light. Unusually for the time, the artists both began to dye their hair red or bright orange and wear what was considered extravagant make-up. They clearly delighted in the freedoms afforded by the liberal and creative milieu in which they had won a place. Far from being simply objects of interest, both women were active creatives, with an intelligence and wit that could withstand the highly cultivated and progressive court of Stein.

Although they would spend the rest of their lives together, sometimes collaborating on work and always delighting in behaving outrageously, they had independent artistic practices. During a visit to Munich in 1904, Mars learnt how to create colour woodblock prints and her subsequent painting and prints are characterised by a simplicity of form, bold lines and strong colour. Woodblock printing was well suited to studio work and naturally appealed to women artists, who may have resisted or not had proper access to lithography, which requires industrial studios, or etching, which involves potentially harmful acids.

Mars taught other artists in her circle how to create woodblock prints. Her best work from her time in Paris borrows from Matisse and Édouard Vuillard, combining strong forms and a knowing reduction of narrative to humorous effect, as seen in *Nice* (c.1903-11). In a compact snapshot, Mars effortlessly captures two women taking a stroll, seen in profile as if we are walking past them, quickly taking the pair in. One cuts a young, elegant and fashionable figure, the other older woman far less so, and both are framed by palm trees and rendered in Mars' signature bold form and lively colour.

Squire's work has a greater reliance on drawing, and in this period, she mainly focused on book illustrations and colour etchings. Her work depicting the same city, *Nice (Am Strand)*, has a looser more expansive quality than the woodcut by Mars, despite capturing a larger group of figures. She presents a timeless beach scene: there are no defined faces, no single story, rather a group of bathers in repose, swimming and watching children about to leap into the water. The forms are quickly found in pencil lines and the scene is finished with a colour wash.

The work of both artists attracted a receptive audience. Mars regularly exhibited in Paris and in the United States and was a member of the Société des Beaux-Arts. Her work was selected by the jury of the prestigious annual group exhibition, the Salon d'Automne, of which she became an elected member. Squire was also selling work both at home and in Paris, and was a member of the

Société Salon d'Automne and the Société des Dessinateurs Humoristes, which granted her voting rights as to who should be able to join and exhibit as well as the opportunity to show her own work.

The carefree lifestyles depicted in their works and the artistic and social privileges enjoyed by the artists came to a halt at the outbreak of the First World War. Mars initially worked as an ambulance driver, but for safety reasons the pair returned to the United States and found a new spiritual home in the artist colony of Provincetown, Massachusetts. Their presence further attracted other artists, as by now both Mars and Squire had international reputations. They became part of a circle, including Bror Nordfeldt, Blanche Lazzell and Edna Boies Hopkins, that experimented with a new kind of printing technique. It combined European influences of cubism and fauvism with the simplicity of Japanese printing.

Having left their mark on what became known as 'Provincetown printing', in the 1920s the artists relocated to Vence in the French Riviera, which was another haven for artists. They each made prints and paintings, and collaborated on children's book illustrations until they retired in the 1930s. They left their home only once to shelter from the Second World War in Grenoble. After the war, they lived out the rest of their days in Vence, no doubt enjoying anecdotes featuring their controversial appearances and behaviour during their Parisian youth. Squire died on 25 October 1954; Mars followed her lifelong artistic companion, friend and lover on 23 March 1959.

Their artwork has been the subject of renewed attention since the turn of the twenty-first century, featured in exhibitions and museum collections. They are now rightfully claiming a place in history, which celebrates their dedication to live an alternative lifestyle and commitment to both their art and each other their whole lives.

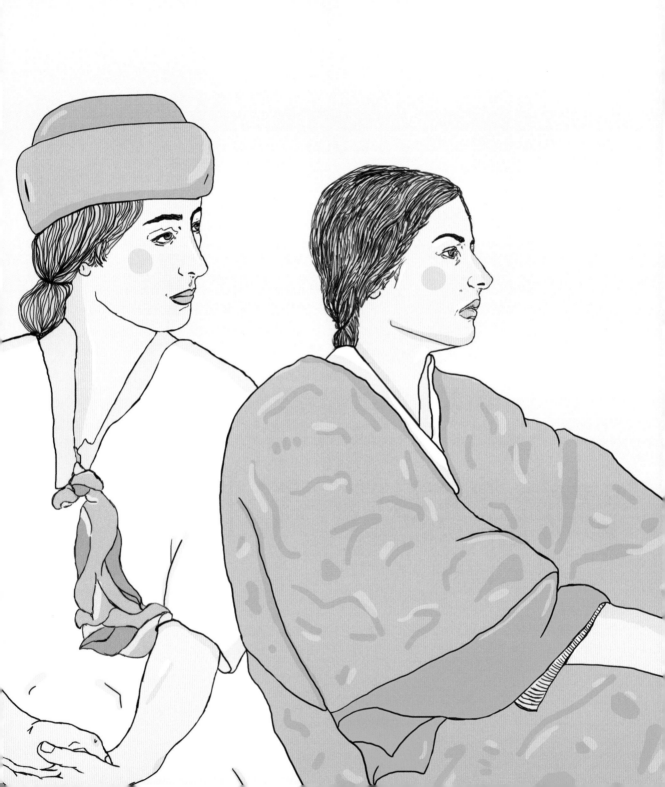

Frances Loring

&

Florence Wyle

c.1903–1968

Known as 'The Girls', Frances Loring and Florence Wyle are the old masters of Canadian sculpture. Although affectionately employed, the name 'The Girls' is misleading. It is unfortunate for its overtones of frivolity and youth when both women were ardently serious about their art and lived for eight decades. However, it is undoubtedly a useful term when used where the English language fails. Historically, there had not been a word to describe lifelong companions of the same sex; the territory was too dangerous, so the unspoken nuance of their lifestyle was safely wrapped in 'The Girls'. It is easy to assume that two women who lived together for their whole adult lives, never married and wore masculine clothing were lesbians. However, Loring and Wyle never described themselves in these terms; they were noticeably mute about their private lives and had a close circle of protective friends who maintained their silence even after the deaths of The Girls. Although we may never know anything of their sex life, what is more important and abundantly clear is that to Loring, Wyle was the most important person in her life, and vice versa. They broke gender stereotypes, and the depth of their companionship, camaraderie and love is explicit from the accounts of their fascinating lifelong bond.

Their heyday lasted from 1920 to 1950, a time when Europe and the United States were in the throes of modernism. But Canada, their adopted homeland, was still a young country with a minuscule art world and The Girls were responsible for exporting classical sculpture to Toronto and setting a new standard for the profession. As significant as it was, their achievement was by no means easily won nor fully appreciated in their lifetime. In Canada in the first decades of the twentieth century, sculpture was still considered a far inferior art form to painting. It was extremely expensive to produce and with scant opportunities for exhibition, it was a profession almost entirely dependent on winning the slither of commissions available. Worse still for Loring and Wyle, to be a woman sculptor was something of a contradiction in terms, such was the accepted wisdom of the macho art world.

Of course, the attitude was not localised; they had experienced sexism in the United States. Wyle was accepted at the Art Institute of Chicago in 1903 and her work clearly made an early impression. When she was a senior student, a group of patrons saw her work and enquired after the artist to undertake a commission. They retreated when they discovered she was a woman, embarrassed but unable to take the risk. Experiences like this no doubt compounded Wyle's proto-feminist stance, a position she adopted from a young age. She was born with her twin brother in Illinois in 1881. Her father valued his son over his daughter and was a disciplinarian with no interest in the arts. A lifelong tomboy, Wyle learnt to make her own way and lived in contradiction to what society expected of her.

Born six years later in 1887 in Idaho, Loring had a very different childhood. Her father was well educated, valuing both the arts and women. As a young girl, she lived in various places in Europe and it was in Switzerland at the age of 13 that she developed a passion for handling clay, later studying sculpture at the Ecole Supérieure des Beaux-Arts in Geneva. When she was

A bust of Frances Loring.

Florence Wyle

A bust of Florence Wyle.

Frances Loring

20, the family returned to the United States and she enrolled at the Art Institute of Chicago, where she met Wyle, who was now a tutor. There were lots of factors that came into play for these women to become The Girls. Wyle overcame a domineering father with antipathy towards her passion, financially supported herself and made herself stand out among her peers in order to obtain teaching status. Loring moved between European countries as a teenager and stumbled into Wyle's world at precisely the right moment to become her pupil.

They did not waste their good fortune, and by 1911 the two were living together in New York's Greenwich Village. It was a magnet for the burgeoning avant-garde, and its reputation to conservatives was one of licentious dens of deviance masquerading as artist studios. Despite the fears of their parents, The Girls made progress, each producing key works in a time of excitement and speedy growth in the New York art world. Loring's father could not stand the scandal of the bohemianism, though, and while they were both out of town he cleared the studio and vacated their apartment, thus bringing their New York moment to an end.

Ironically, it was this act of paternal intrusion that led Wyle and Loring to settle in Toronto. Loring's parents were by then living in Canada and Mr Loring lured them to their new home by agreeing to finance a studio for the pair. They were established quickly and their quirky home received a constant stream of social calls from artists and musicians. Although they lived through financially strained times, due to the inconsistency of commissions for each artist, they were permanently generous hosts. Loring, referred to as 'Queenie' by Wyle, was a self-assured extrovert who wore silks and exotic shawls. Wyle, by contrast, was reserved, deferential and more likely to wear a shirt and tie; she also always wore her hair short.

Similarly, there were major distinctions in their sculpture. Wyle tended towards the earthy, empathetic, serene and still, whereas Loring created work that was powerful, more dynamic and without rest. Although they took very distinct approaches, they were resolutely united in their burning passion for sculpture, believing it to be the highest form of art since the Greeks and shamefully overlooked by the art world they inhabited. They maintained their enthusiasm and stubbornness on this position, despite financial hardships and lack of recognition for their long careers, which enlivened and illuminated the art scene when they arrived.

By their old age, their health was failing and their work was out of date. They were overlooked in favour of modern pieces: their love of classical art meant that they had always disliked abstract artists such as Henry Moore and were even more appalled to see sculpture fashioned from non-traditional materials. It was probably hard to recognise them as pioneers by the time they were in their 80s, but those who knew them well would not have forgotten. Despite various physical impediments, they wilfully lived unassisted and made work until their final months. Their sexuality was not spoken of, but there is something explicitly romantic about their deaths. In 1968, they left the world just three weeks apart, having lived in it together with absolute vibrancy for nearly 60 years.

Florence Wyle

Alexander Rodchenko

&

Varvara Stepanova

1910–1956

Today, a Western artist may be political personally, but there is no major impetus for them to give expression to their politics in their artwork; it can happily exist independently from world events. This is not true of Russia 100 years ago. To take away the politics of husband and wife Alexander Rodchenko and Varvara Stepanova would be to extinguish the purpose, meaning and relevance of their art and life together.

They met at the Kazan Art School in 1910 and started an intense partnership that was always in service of something bigger than the two of them. They moved in together in Moscow in 1916 but did not marry until 1942. Their courtship played out against the turbulent backdrop of the final period of a nearly 200-year absolute monarchy. The Russian Revolution of 1917 changed the world order, and nothing was ever the same again for the millions of peasants who suddenly became new heroes, emerging from a broken and outdated system. Rodchenko was born in 1891 to a washer woman and Stepanova was born three years later into a peasant family. Consequently, both artists would have known acutely what the Bolsheviks and Lenin were fighting to eradicate.

The Russian avant-garde was dynamic and radical in its quest to find new forms of expression for a society that had been newly reborn from the ashes of the past. An indication of how strong the reaction to the old world order was can be found in the concerns of Stepanova in 1917. This was the year that she began writing non-objective poetry. Rather than creating poems that were text based, her work was visual and words were chosen simply for the quality of their sound or appearance, eradicating a necessity to be 'read' and instead creating a visual and sound experience. Photographs of her at that time show her wearing her hair short and angular; she had the androgynous look of an artist comrade. Rodchenko wore his hair closely shaved to his head; decoration and fuss were as exempt from their lives as they were from their art. They described themselves as 'creator rebels'.

In 1918, Stepanova published her experimental work in manuscript form. She was essentially making unique pieces of graphic art and destroying normal distinctions between writing and visual art. In the same year, Rodchenko painted and exhibited his *Black on Black* series, eight paintings that were a direct response to the more established artist Kazimir Malevich's white paintings of the same year. Praising her partner's work over that of his elder, Stepanova revealed the kind of competitiveness at play: *'Where the black works are winning is in the fact that they have no colour, they are strong through painting . . . Nothing besides painting exists.'* Malevich's work was considered the end of painting; it had reached its zenith by taking away subject matter and entered an abstract spiritual realm. In contrast, Rodchenko rejected spirituality as the new purpose of art and instead drew attention to the very materials of the painting, separating outline, colour, surface, texture and form. Construction was the new composition, hence the term 'constructivism' to describe the work of Rodchenko and this avant-garde group.

Rodchenko and Stepanova evolved from this embryonic stage of investigating what art could and should be. It was a period in which they both seemed in danger of tying themselves in knots, making obscure work still rooted in the world of fine art. By the 1920s, both artists had committed themselves to finding a way to utilise the arts for social progress and to sever the relationship with the navel-gazing world of galleries and museums.

Alexander Rodchenko

Instead, they turned to the field of design to help them unify politics and art, to create something of true purpose and value in everyday life. In 1921, the couple became key figures in the First Working Group of Constructivists. Rodchenko recalled: *'We had visions of a new world, industry, technology and science. We simultaneously invented and changed the world around us. We authored new notions of beauty and redefined art itself.'*

Rodchenko was an established name in the young Soviet Union: in 1920, he was appointed the director of a newly created museum body that took art from the now-dismantled elite and presented it to the public. He acquired nearly 2,000 works of modern art and opened 30 museums throughout the provinces of Russia. Art was fundamental to the new society and it was now in the hands of the masses not the rich. His graphic design work, which promoted Soviet principles and products, is today very fashionable and influential. There is something ground-breaking, noisy and radical in the language he created that still resonates.

In some respects, Stepanova was even more successful than Rodchenko in using art as a tool for the common good. By the mid-1920s, she was working in textile design and had 20 of her 150 striking geometric designs mass produced. An iconic 'industrial art' work of 1928 is a unisex sports uniform that demonstrates the fundamental honesty of her approach. She valued simplicity, function and the very materials themselves. She thought carefully about how the body moves, how it might best be served by the garment. Conversely, she also considered how the garment might best be respected by the owner; by drawing attention to the seams, weaves and other construction features, the origin of the piece is evident. Stepanova is today considered pioneering not only for her futuristic-looking designs but for being a sustainable designer decades before the modern concern with the environment.

Stepanova no longer considered herself an artist; she was an artist-engineer or 'productivist', aiming to reach the broadest audience and to assist the development of the new Soviet society.

Both she and Rodchenko could be described as idealists: they sacrificed everything for the cause that they believed was fair and equal. When Rodchenko visited Paris, he wrote to Stepanova, appalled at the *'West's cult of woman as object . . . only a man is a person but women aren't people . . . you can do what you want with them.'* They lived the kind of life that they believed should be available to all, subverting gender norms and social expectations.

The constructivist experiment ended less than a decade after it began. Very few artists and writers survived under Stalinism in the 1930s, but Stepanova and Rodchenko were very adaptable. They were optimistic by nature and found strength in each other. Still, it is a sad image to think of them burning Rodchenko's sculptures in their Moscow apartment during the bitter winter at war of 1943. Temperatures outside were minus 30 degrees and the art was the thing sustaining life, as it had already done metaphorically for so long. Rodchenko reinvented himself as a photographer in the 1930s, securing his future fame in the West, and died in 1956. Stepanova never recovered and died soon after. Despite the easy equality they found together, Stepanova is still a largely unknown figure. Yet, it is her principles of social activism and sustainability that resonate most strongly nearly a century later. Our society is finally catching up to this pioneer of living, working art.

Varvara Stepanova's unisex sports uniforms illustrate her striking geometric designs.

Varvara Stepanova

Niki de Saint Phalle

&

Jean Tinguely

1960–1991

Niki de Saint Phalle and Jean Tinguely became a couple in Paris in 1960 and were quickly known as the Bonnie and Clyde of the art world. They lived out the bohemian spirit of the age, sexually free and revolutionary in their life and work. What brought them together initially was love, but what kept them together was art. Their partnership is one of the most unusual in the history of art because it was entirely equal, both within their private lives and the manner in which they were publicly received. As independent artists, neither had to deal with one overshadowing the other. In addition, their collaboration preserved each artist's solo integrity while being well received as great work by a married couple.

It would have been difficult to predict the success of the partnership when they first met because they made an extremely unlikely pair. Tinguely came from a working-class background and his work centred on movement, metal and the physical act of creation with his hands. Saint Phalle's family was aristocratic and her colourful work was born of emotions: sensual and abundant. And yet within their relationship, they nurtured a deep mutual trust, one that had been absent from their childhoods and one that fused the pair together, despite the on-off nature of their love life.

Saint Phalle was born in France in 1930 to a strict aristocratic Catholic family. Her father, a count, was a banker and her mother was an unstable US actress. She grew up bilingual in New York and always had a free-spirited and stubborn nature: she was expelled from school for painting red the fig leaves covering the genitals on the school's statues. At the age of 18, she eloped with her childhood friend Henry Matthews and gave birth to her first child when she was 20. She became volatile and mentally unsound when her second child was due, later revealing in her autobiography that her father had sexually abused her since the age of 11. Saint Phalle was encouraged to paint as a form of therapy, while receiving treatment for her serious condition in a psychiatric facility, which completely redirected the course and meaning of her life.

Five years older than Saint Phalle, Tinguely was born in solitude in Switzerland, the only child of working-class parents. He rebelled against the tyrannical household his father led and left home as soon as he could, taking with him a lifelong intolerance of authority. He harboured ambitions to become an artist and attended art school between the ages of 16 and 20. He was deeply influenced by Marcel Duchamp's introduction of the found object in art and embraced all that was counter-cultural, including attending anarchist meetings as a young man. Although he celebrated disorder, he was determined to be successful and by 1951 he had settled in Paris with his new wife, the artist Eva Aeppli.

By the mid-1950s, Saint Phalle and Tinguely had found their artistic voices and were drawn into each other's orbit via a group of Duchamp-inspired artists known as the New Realists. They met within the intoxicating circle of avant-garde Paris at a time when both were fearful that they would become bourgeois, married unhappily and not fulfilling their yearning for a wild life teeming with creativity. In 1960, these concerns and the intense affection they felt for each other motivated Saint Phalle to leave her husband and young children to move in with Tinguely, who had recently separated from his wife. Their union was born from the tatters of their former lives and, despite being tumultuous from the beginning due to their opposing characters and equally big egos, it provided a sound base for each of them to reach new artistic heights.

There was a good deal about the way they approached their artistic practice that was different. Saint Phalle developed a body of work that saw her shoot a gun at bags of paint placed on her canvases to make paintings, relying on chance, action and an aggressive need to relinquish the pain her father had caused. Tinguely, on the other hand, was closer to an engineer, slowly and carefully creating kinetic sculptures with found metal. But there were also shared positions in their practice, namely a rebellion against current trends and attitudes. Saint Phalle was critiquing the god-like, macho

status of the abstract expressionists in New York by using violence and absurdity to create a similar painting effect with her gun. Tinguely made a dark commentary on mass industrialisation and the death of craftsmanship in society. They were both also early exponents of the performative aspect of art: Saint Phalle in the shootings and spectacle of her large sculptures and Tinguely by incorporating movement and creating sculptures that destroyed themselves.

Their collaborative work bears two great egos and two distinct artistic practices, all wrapped up in the ribbon of their shared ambition and passion. In 1966, they created *Hon* (Swedish for 'she'), a gigantic reclining woman that was so vast visitors could walk inside the sculpture via her open legs. Inside what Saint Phalle called a uterus, they found a serviced bar, a fish pond, a theatre and a kinetic sculpture that Tinguely described as an

orgasm machine. The audacious scale, impressive feat of invention and loud provocation could not have been achieved by either artist working alone.

After more than a decade of being together, the artists married in 1971. The service committed them for life; they would never leave each other's world or divorce. However, they were far from being another conventional bourgeois couple; by this time, both had taken lovers and they would never be monogamous again. Such was the radical nature of their partnership that they would break up with their new sexual interests if the other did not approve of them. Their principal concern with their spouse was not faithfulness to love but to art: they were sparring partners, support mechanisms and influential collaborators. Their union was a Pandora's box, at times painful but endlessly apt for reinvention and powerful new creations.

Niki de Saint Phalle often shot a gun at bags of paint placed on her canvases to make her paintings with the aid of violence.

Jean Tinguely

Leon Golub

&

Nancy Spero

c.1949–2004

The US artists Leon Golub and Nancy Spero have been described as the conscience of the art world. Between them, they called out abuses of power, corrupt politics, sexual inequality and social hypocrisy in an unrelenting fashion. Their artwork could be visceral, shocking and provocative, often employing disturbing imagery of bloodied bodies, machines of war and the voices of broken, cynical souls. They constantly asked what the artist's role was in the face of social injustice, violent wars and corrupt power structures. They were the original radical artist activists and stayed true to the cause for more than five decades.

Despite the cacophony of horror they each conjured in their artworks, their life together was harmonious and nurturing. Somehow the fury of their work did not give way to a real-world nihilism, and the pair lived very happily together in a warm, supportive marriage. Although they worked independently, they knew each other's art inside and out, and were perhaps the best authority and critic of the other's output. Interviews reveal them to have shared a very deferential, generous attitude with one another, which seemed at odds not only with the ferocity of their art but also with their cool comportment. Like most radicals before them, their uniform was black: Spero wore her hair pixie short alongside her husband's bald head. They posed for photographs like rock stars, fierce and serious. They did not have anything frivolous to say in their art; it was made as both a rallying cry in the face of universal suffering and a panacea to release their painful frustrations. The private

harmony they enjoyed was partly a result of their careful detachment from what they perceived to be an unwelcoming art world.

They met as art students at the Art Institute of Chicago in the late 1940s. Golub was among a number of young GIs just returned from war studying art at the college. After graduating, they married in 1951 and the artistic backdrop to their early years together was dominated by abstract expressionism. The artistic phenomenon was self-referential and entirely apolitical. It was dominated by large abstract paintings and even larger male egos. Figuration and women were pushed to the margins; they were each starved of oxygen in the heady smoke-filled rooms of artistic meeting places such as the Cedar Tavern. Spero witnessed the way in which women artists were disregarded, especially Lee Krasner and Elaine de Kooning, the wives of the most famous painters. Golub shared his wife's reticence about the prevailing artistic climate: his painting was centred on the human form and human stories, and he feared he would never be taken seriously in this abstract-obsessed period. Rather than resign themselves to adapt in order to be able to play with the big boys, Spero and Golub simply left New York and built their own universe for two in Europe, in communion with the great art of the past. In Italy and Paris between 1959 and 1964, the artists brought up their two young sons and had a third child. Their time in Europe was museum-filled, happy and detached. They each found great inspiration in ancient Roman and Etruscan figurative art with its themes of power and violence, motifs that came to dominate their modern lives.

When the pair returned to New York in 1964, the escalating civil rights movement and raging Vietnam War dominated the news: watching each night, they felt they had suddenly lost their innocence. They were shattered, and Spero recalled: *'When we came back from Paris and saw that we had gotten involved in Vietnam, I realised that the United States had lost its aura and its right to claim how pure we were . . . I realised how guilty we were as Americans.'* In this period of bitter frustration at the events that were shaking

the foundations of their country, the artists each developed important bodies of work that marked them out as pioneering artist activists. They took one large studio in LaGuardia Place, which was divided by a wall to create working space for each artist. Although the pair were inseparable and constantly locked in conversation about social responsibility, their art took very different forms.

Spero began her *War Series* in 1966, dedicating five years to an unrelenting focus on the violence of those times depicted in fast, furious gouache drawings on paper. There was not always much on the page, but what was there exploded in its horrible combination of human form and machinery. Her symbol of Vietnam was the helicopter, a motif she repeated often, lending it sexualised shapes and allowing war to take a female form. Spero followed this with work that took direct inspiration from the writings of the French poet and playwright Antonin Artaud, who was confined to institutions in the 1930s and 1940s because of mental instability. Spero felt an affinity as a marginalised woman artist: *'I chose to use Artaud's writings, because he screams and yells and rants and raves about his tongue being cut off, castrated. He has no voice, he's silenced.'* Fusing image and Artaud's furious words, Spero developed her signature scroll paintings, large archival sheets of paper glued together and presented across the gallery walls. The scroll form and the fusion of an obscure mentally unstable poet with Spero's esoteric imagery broke modern conventions, and the fact that this large provocative work was made by a woman marked her out as a radical force.

Golub's radical spirit was as loud as his wife's, and in fact Spero always cited him as giving her the confidence and impetus to voice her dissent. Since serving in the war, Golub had been political and articulate about the complexities of violence, but it was upon his return from Paris that his politics permanently fused with his art. Like Spero, he immediately addressed the horrors of the Vietnam War in his *Napalm* (1969–73) and *Vietnam* (1972–74) series. His work was far larger and less abstract and centred on allowing the human

Leon Golub used his art to explicitly criticise the Vietnam War.

figure to speak of atrocity, violence and pain. His figures are at once real, young Vietnamese men with guns pointed at their heads, but also like characters on a stage set: classical incarnations of depressingly universal and oft-repeated periods of humans killing humans. In the 1980s, Golub took the language he found during the war and applied it to portraits of dictators and politicians, such as Fidel Castro and Richard Nixon, and later made series based on terrorism, brothels, torture, and racial and gender inequality.

Just as Golub had inspired Spero to merge politics with art, Spero in turn inspired Golub's work on gender norms. From 1976, Spero became female-centric in her art, rejecting the male figure entirely and dedicating her work to gender inequality on a global scale. She was a key part of the women's art movement and a founder of the pioneering all-women gallery AIR in New York City in 1972. Having originally felt like outsiders,

Golub and Spero became insiders by lending their work a social and political conscience. They were hugely influential artists and internationally recognised in their lifetime. In addition, they were both unflinching in their responsibility to speak of injustice and the essential violence of humankind. Golub and Spero found strength in one another, privately doting and publicly unrelenting in their interrogations.

After Golub died in 2004, Spero continued to work in the studio for seven years. The room was divided as ever into their two respective halves. To replace the comforting presence of her lover and sparring partner, she kept one large Golub painting attached to his studio wall. Through the canvas, his energy still filled the space, just as Spero's art does in museums and galleries around the world today. Their service to art activism was great, and their conscience lives on in their powerful work, their voices undiminished.

Nancy Spero

Lili Elbe

&

Gerda Wegener

1903–1930

Einar and Gerda Wegener married in 1904, after meeting at art school in Denmark. Einar was 22, specialised in landscape painting and was smitten with the young Gerda, who would soon become a well-known magazine illustrator and portrait painter. However, 26 years later, their marriage was annulled by King Christian X, as Danish law did not recognise nuptials between two women. For, in 1930, Einar Wegener became one of the first people in history to undergo sex reassignment surgery. After successfully transitioning, she chose Lili Elbe as her legal name.

Theirs is a story of love under extremely difficult circumstances and the pursuit of personal happiness in a pre-modern era barely equipped with an understanding of the complexities of gender identification. Elbe's bravery, resilience and determination saw her rectify what she came to believe was a biological error. By her 20s, she had grasped that she had been born into a man's body and would be tormented until she could become a woman. Gerda Wegener may not be the medical marvel in this couple, but she was a wife who displayed a psychological sensitivity, unconditional love and emotional maturity in her full support of her partner's transition from Einar to Lili.

In their youth, both artists demonstrated a dedication to their artistic abilities: they each forged distinct career paths soon after graduating from The Royal Danish Academy of Fine Arts. Wegener's work was selected for exhibition the year they married and soon after she won an art prize organised by the newspaper Politiken. She quickly found a larger audience and soon she would become one of the leading illustrators in women's magazines, portraying slinky figures modelling the latest fashions for Vogue magazine. She was also a distinguished portrait painter and often worked from life models. It was happenstance that on one occasion a female sitter did not show up for a modelling session and Wegener persuaded her partner to stand in, wearing women's heeled shoes and stockings. This is considered a pivotal moment for Elbe who, comfortable and happy in this mode, would regularly pose for Wegener in women's clothing, later explaining: 'I felt very much at home in them from the first moment.'

Wegener's sensual evocations of a fashionably dressed, slim muse with bobbed hair and almond-shaped eyes were a huge success. Unfortunately, when the identity of the sitter was revealed, the small conservative Copenhagen art world was scandalised. Attracted by its liberal bohemian society and the prospect of a lifestyle where Elbe could eventually identify permanently as a woman, the couple moved to Paris in 1912. Wegener's paintings became increasingly erotic and her nudes with sexualised poses

and expressions were a great success in their avant-garde circle. The couple attended balls, at which Elbe was presented as the sister of Wegener and enjoyed the attention of male guests. Wegener was fully supportive of Elbe's position, often encouraging her spouse in new pursuits that exploited her feminine persona. Theirs was an unconventional marriage for more than a decade. They threw parties at their extravagant Parisian apartment, two slim women in the latest fashions, and enjoying Wegener's success in the art world.

By contrast, increasingly Elbe painted less and her art career dwindled to a halt as her energies were expended in the fulfilment of finding someone to help her achieve her dream of transitioning from a man's body to a woman's. At the age of 47, after trying and failing for many years to seek help, she entrusted herself to a series of pioneering operations in the German clinic of Dr Kurt Warnekros. The expensive fees were generated by Wegener's painting sales. Indeed, it was the convincing image of Elbe as a woman as portrayed by her partner that allowed the surgery to make the image a reality.

It was in the Dresden clinic that Elbe chose her new name, after the river that ran through the city of her rebirth. Elbe's case was widely reported in newspapers and her emotions ranged from joy at the successful transition to extreme fear and anxiety over whether she would ever be accepted by society at large. She had now stopped painting altogether, feeling that it was a career that belonged to her former identity. Legally her marriage to Wegener was annulled and she was issued a new passport under her chosen

name, Lili Elbe. The two women continued to show great affection for one another, despite the notoriety that engulfed the end of their marriage.

Unfortunately, Elbe enjoyed her womanhood for just 14 months. In 1931, she died after undergoing her fourth operation, designed to transplant a womb in order that she might be able to conceive children. Unwell with a serious infection and showing signs of fatal deterioration, Elbe wrote to a friend, poignantly expressing: 'It may be said that 14 months is not much, but they seem to me like a whole and happy human life.' Lili's passing was bitter sweet; she sought satisfaction in having found her right place, however short lived. Wegener went on to marry again, but her Italian husband depleted her savings and left her broke and alone five years later. She returned to Denmark, with no family of her own and an out-of-date painting style that no longer afforded her a fine life. She drank away her final years, the former toast of bohemian Paris painting postcards to eke out a meagre income.

It is only in this century that Wegener and Elbe's legacy is being widely and fully appreciated. Their marriage has been the subject of best-selling books and the Oscar-winning film The Danish Girl (2015). As well as rightly being considered pioneers in the field of non-binary gender roles and sex reassignment surgery, Wegener and Elbe are also being reconsidered and appreciated as artists. Wegener's work is enjoying new-found success at auction and in touring exhibitions. Her dazzling visions of Elbe, at once so vulnerable and yet so sensually assertive, speak to us directly from the bohemian world that took them in and allowed them to be who they needed to be, a century before the world at large might have done so.

Gerda Wegener

Bernd Becher

&

Hilla Becher

1957–2007

On the one hand, one could argue that the photographic collaborators Bernd and Hilla Becher demonstrated an absolute clarity of purpose. It must, therefore, be simple and straightforward to understand their endeavours and legacy. In a single-minded, matter of fact manner, they spent more than 40 decades documenting utilitarian architecture in their native Germany and beyond. Their large-format, frontal approach was analytical, finely detailed and objective. Theirs was not a photographic practice that allowed for soft focus, creative perspective or special lighting. The work has a formula and a consistency of method so devoid of personality or expressiveness that one might struggle to see it as art. They presented an exhaustive inventory of industrial structures, including water towers,

blast furnaces, winding towers, kilns and gas-holders. Their subjects were not art historical and they did not exist in a shared cultural legacy. They remained the preserve of an industrial realm never considered relevant or visible to the art world and its creative agency. The Bechers then might seem clinical practitioners of documentary photography: their contribution is manifest in the records they created and their purpose and significance clearly marked out.

And yet, this can only be part of their story. There may be no expressive qualities to their formal approach, but the overall effect of such a long and sustained focus is to reveal a very human quality: a profound passion and niche obsession. Their great and shared love was esoteric and it was for utilitarian architecture. As much as the

pair insisted that they used an entirely objective approach, the complex categories and systems they worked to meant hundreds of decisions went into every shot. Their work aimed to present the very essence of its subject, without distortion or interpretation, but their burning desire to do this very thing singles them out as unique image makers, for only the Bechers could make work like this. In its extreme and precise repetition, the subtlety of their approach begins to ring in one's ears. It is no longer quiet; the Bechers can be heard constantly. It is also far from clinical; rather, it is a body of work that is, by its very reason for existing, deeply nostalgic and urgent in its mission to capture a disappearing world, one of childhood games and fictions. Describing how he felt as a young man, Bernd recalled: *'I was overcome with horror when I noticed the world in which I was besotted was disappearing.'*

Bernd Becher was born in 1931 in Siegen, one of Germany's oldest and most important industrial regions. For several generations, his family had been involved in mining and the plant site was his playground. The architecture of the place shaped his understanding of home territory just as much as the church spires that also featured in the local landscape. Preservation was an ethos absorbed while he was still young, learning as an apprentice in his father's restoration workshop, which attended to churches and public buildings. In 1950, he travelled to Italy, working as an illustrator, and made numerous studies of historical buildings, treating his subjects as architectural individuals. By 1957, he was employed in an advertising agency, where he met his future wife and lifelong collaborator.

Hilla Becher was born in 1934 in Potsdam, and after the war she grew up in East Germany. When her uncle departed for the West, he left her his darkroom, and by the age of 14 she was already developing her own photographs. Like Bernd, she benefited from parental influence: her mother had trained as a photographer in Berlin in the 1920s. Aged 17, Hilla began a three-year apprenticeship with a photographic studio in Potsdam. The studio's traditional approach belonged to the previous century, meticulously employing strict formal principles that would have neutered the passions of a bohemian soul. Hilla, on the other hand, thrived. Her first solo project was to compile a documentary record of a railway repair facility, and it was here that she first began to present the sculptural qualities of the metal parts using light and shadow. She needed to find a technique that captured the truth, form and substance of these things. It did not matter that they were

Bernd Becher

not classically beautiful or artistic; for Hilla, the objective was just as serious as if they had been.

Around the same time, Bernd was employing a similar rigour to documenting the plants and mining infrastructure of his childhood, which was being demolished after major economic restructuring to the industry. His pens could not work fast enough and he resorted to using a camera to capture an image to work from after his subject was extinct. The Bechers began working together soon after meeting, and by then the necessary foundations were in place for their productive and specialised joint career. They married in 1961 and their preoccupations were far from those we might expect of newly weds. They dedicated themselves to the comprehensive documentation of the industrial architecture that was fast disappearing. Where the state failed to act, they did.

The industrial age was long considered a necessary evil, removing man from a close relationship with the land and even from a spiritual connection. It is partly this legacy that makes the Bechers' choice of subject so unusual and seemingly cold, mundane or uninspired to some. However, their work found huge sympathy in the burgeoning conceptual art world and the Bechers were often included in exhibitions that dealt with minimalism. They seemed to shrug off questions about the artistic nature of their endeavours; they did not see it was important to meet distinctions of what art is or should be. We might understand their position better by picturing them with their young son, Max, travelling around the industrial heartlands of England and Wales in 1966. They created a travelling universe of their own: mother, father and son in a VW van with a caravan attached, acting as a darkroom. Their pursuit was so authentic that it did not have time for artistic labels; they sacrificed conventional comforts for a nomadic existence, carrying out their work across Europe and the United States.

They may have been workman-like in their staunch choice of subject, but their devotion is evident. The Bechers created a legacy of enormous impact in the contemporary art world, directly shaping the Düsseldorf School of Photography and artists such as Thomas Struth, Thomas Ruff and Andreas Gursky. Their work is not an encyclopaedia; rather, it is a requiem for a dying realm. Only such fine attentive photographers can attain beauty where others see ugliness. The best art is transcendent and without self-consciousness. By some miracle, Bernd and Hilla found each other at just the right time to carve out a lifetime of enthusing over an unloved, overlooked and disappearing world.

Hilla Becher

Emilia Kabakov

&

Ilya Kabakov

1989–present

The Kabakovs invent characters, conjure fake worlds, disguise themselves in their work and employ highly complex artifice that is so believable that it no longer feels like a pretence. All of this is done not to trick the viewer but, conversely, to create powerful metaphors that might speak the truth better than simple facts. Their language relies on falsehoods, but their endeavour is to communicate something authentic. It is little wonder their position is one of artistic subterfuge; in many respects, it is a marvel they exist as an artistic duo at all. Ilya and Emilia Kabakov endured Russia's Soviet rule, during which living conditions were extremely poor, life was highly controlled, conformity was a means of survival and personal aspirations were deeply repressed. Yet today, they are internationally recognised stars of the contemporary art world, pioneering in the field of 'total installations' and hugely influential for a younger generation of artists. This must have felt like an impossible dream to the young artists living in the Soviet Union.

The Kabakovs have known each other their entire lives. In fact, they are second cousins from the same town, Dnepropetrovsk, and are 12 years apart in age. Emilia is the confident, organised, effective spouse and Ilya, prone to insecurity, is the introverted contrast. Emilia left for Israel in 1973 after reaching breaking point with Soviet life: as an outspoken woman holding her tongue, she said she either had to leave her friends and family or go to jail. The pair were in love, but not married. Ilya drove her to the station with a heavy heart; part of him wanted to escape with her, but he could not sever ties with his home. He was especially committed to his mother who had endured serious hardship, living through the horrors of revolution and war, and yet remained a constant source of support as his single parent. Ilya's decision to stay came at a great cost, for they did not see each other again for 13 years. Emilia had been a professional pianist, but when she left she reinvented herself, and worked as an arts advisor, art dealer and curator for Deutsche Bank.

For the first 30 years of his artistic life, Ilya worked as a solo artist, not only without Emilia but also without an art world: his work was clandestine and dissident. Now in his 80s, he talks with fresh sadness about these 30 years as an official artist for the Soviet Union, recalling: 'You always have a mask.' After studying at the Moscow School of Fine Arts, Ilya chose illustration for his career path and created children's books for state publishing houses. This began his double life as an artist: working a few months a year in an officially recognised capacity to earn a decent living, while using the remainder of his

Ilya Kabakov was an official artist for the Soviet Union for 30 years, but in his private domain broke the prescribed rules of artistic production.

time to create unsanctioned art in his own private universe. He reminds us: '. . . *life at that time was very dangerous . . . the studio was always locked'.* This was work that was shared only among his trusted artist friends. They existed in a vacuum, with no contact with art developments at large in the West, no collectors, no critics. Today, this group is known as the Moscow Conceptualists and widely praised.

The fact that their art was not exhibited was beside the point; it was art created as a silent bid for freedom. Ilya played with the dictates of the state's official art programme, social realism: saccharine painting that promoted the Soviet Union's aims and objectives. As part of his strategy of disguise and misdirection, Ilya made paintings that would easily be mistaken for official art and then deftly subverted the genre by adapting both physical qualities and undermining the intended meaning. *By December 25 in Our District . . .* depicts a grim construction site. To the left is a long list of all the construction work promised in one district, including two stadiums, a library and a hospital. Affixed to the surface are two real shovels absurdly suspended in mid-air, a radical gesture of conceptual art in a deeply conservative world. More dangerous still is the irony. The shovels are ineffective and act as a metaphor for the empty promises of state propaganda; the proclamation depicted dates from 1979 and the painting from 1983 – when nothing had been achieved.

In addition to publishing 150 children's books officially, Ilya was making albums that told the stories of invented characters who all lived fearful, deprived lives. He also began to use found materials to create small installations in his apartment. Somehow, his ambition managed to grow without light in the dark world of his locked studio. But it was fragile, and did not bloom fully until he moved to the West and began working with Emilia in 1989. In this period, the underground Russian art world slowly came to be known to a handful of Western curators, and word quickly spread among art collectors that important and inexpensive work was coming out of the Soviet Union. Ilya was invited to exhibit in Paris and never looked back.

The pair have not wasted any time since being reunited. They married in New York in 1992 and Emilia has fully archived Ilya's entire unofficial artistic practice: no easy feat for artwork made and disseminated in secret. Initially, she considered herself his assistant, helping him manage the demands of the art world and navigate a move from private to public spheres of activity. But Emilia began to do more than just assist; she became a collaborator who helped Ilya make sense of his ideas and allowed them to be bigger. Ultimately she is a large reason why they are pioneers in the field of installation art.

Working closely together, they pioneered a form of art described as 'total installation'. *The Man Who Flew Into Space From His Apartment* (1985) is a masterpiece of immersive storytelling: the narrative is pure fiction and yet there is nothing deceitful about the message and sentiment. The artwork is an entire room, the characterless dwelling is abandoned and the walls are covered with tatty propaganda posters. The protagonist has long since projected himself through the ceiling in his homemade catapult, leaving a

violent hole in the ceiling and blueprints of his imaginary contraption on the walls. In this one room, the Kabakovs speak of the hope and despair of a totalitarian regime and the failed space race; they allow one invented man to speak of an entire generation stuck leading double lives in their own homes. They are conductors of a potent mix of humour, irony, pathos and tragedy.

Despite the extraordinary complexity of the installations they built, there remains a sense of detachment from the past. It is a painful and difficult history and one that they investigate through various prisms. One they have avoided, though, is nostalgia, and Emilia flatly states: *'You have to be incredibly stupid and primitive to do that.'* Perhaps this is also why their private life is hard to pin down. They find questions about their marriage inane and find it 'dangerous' to talk about how their artistic partnership works. The closest they come to revealing something of themselves is *Labyrinth (My Mother's Album)* (1990). The large depressing installation leads down a claustrophobic corridor with recordings of Ilya singing the nursery rhymes of his childhood. The walls are covered with photographs of Russia as well as pages of Ilya's mother's autobiography. When speaking of mother Russia, Ilya for so long had used pseudonyms, kept his work hidden and remained in the shadows. Now, when speaking of his own mother, Ilya and his wife permit themselves to visibly author the story and preserve her memory. They flew through the ceiling to secure their freedom to do so.

Ilya Kabakov

Tim Noble

&

Sue Webster

1986–2013

The British artistic duo Tim Noble and Sue Webster are always fighting: for acknowledgement as outsiders, against the perceived notions of their audience, against the refinement of the art world and as a combative couple between themselves. In the highly personal post-punk universe they have jointly cultivated, Noble and Webster's art and life are entwined in a dangerously passionate, at times claustrophobic, and always provocative way.

They met in 1986 at art school in Nottingham and found in each other a shared preoccupation with punk music and its edgy, derisive demeanour. They were both outsiders who gravitated towards punk's unconventional space for angry otherness. Too young to be original punks, they lived the movement once removed as solo teenagers, protectively adopting black clothing and eyeliner. Webster was born in Leicester in 1967 to an electrician father who taught her how to wire lamps and a mother whose happy and traditional working-class female sphere of existence panicked tomboy Webster. Noble's upbringing in Stroud was decidedly more rural; he was born in 1966 to liberal artist parents and spent much of his boyhood alone, improvising flying machines and motorised objects.

Art school promised escapism for them both. They had each rejected painting and were independently making work using found materials: Noble was keen on motorised pieces after seeing

Jean Tinguely's work at the Tate. They did not make art together as undergraduates but travelled together, taking a greyhound bus from New York to Los Angeles and collecting scrap metals along the way. After graduating in 1989, they gravitated not to London's art centre but to Bradford, where they could afford enormous studio space, surround themselves with junk yards and have no social expectations or niceties. They made a living creating stage sets out of junk for rave concerts. It took a colossal interruption into the natural order of the London art world, in the form of Damien Hirst's *The Physical Impossibility of Death in the Mind of Someone Living* (1991) – a shark preserved in formaldehyde – for them to make the 200-mile journey out of their metallic wilderness. Webster recalls: *'It was a punch to the stomach.'* The duo realised they needed to be part of the controversial, often antagonistic art being made in London by a disparate group of artists who came to be known as the YBAs, or Young British Artists. It was a new counter-cultural movement and it was open invitation.

By 1996, after two years at the Royal College of Art with only Noble an officially enrolled student, the duo found themselves living in the no man's land of Shoreditch in east London, a new Mecca for the YBA scene. They began making light-based work, and even these early pieces demonstrate the concentrated duality at the heart of everything they went on to create: at once cynical and celebratory, sentimental and comic, chaotic and quiet. *Excessive Sensual Indulgence* (1996) is a pulsating, 6-foot (1.8-m) fountain of light, which speaks of kitsch, dead-end British seaside towns and the glorious bright lights of Vegas that so entranced the artists as young students on their road trip. Their work was up for a fight, louder and more foul mouthed than the more established YBAs. They enjoyed projecting an aggressive, nihilistic spirit, but despite dressing alike and finishing each other's sentences, the artists have often spoken about

their distinctive natures. Noble is the day dreamer and needs Webster's practical forcefulness to get things done.

In 1997, the other half of their artistic oeuvre, the shadow work, became the yin to the yang of the light work. Mirroring their personal lives, they needed two alternative modes of being and ways of seeing to create a whole. It is perhaps their shadow work that best exploits the contradictory nature of their practice and reveals the most about the artists. *Dirty White Trash (With Gulls)* (1998) was created using six months' worth of studio rubbish, and in daylight it looks exactly like that: a rubbish tip with two taxidermy seagulls feasting on discarded chips. Once illuminated, every single discarded item plays a part in rendering a complex and precise silhouette of Noble and Webster sitting back to back enjoying a drink and a cigarette. The duo play with two distinct impressions: an initial revulsion and an illusionary grandeur. They insist that their audience considers the very nature of perception and how value is formed. The first medium of the shadow work is detritus – their own or that scavenged in east London – and represents a throwaway culture moving at terrifying speed, contrasting the transformational second medium, projected light, which encourages a meditation on realism and illusion.

Forever skirting, or more often redrawing, the boundaries of decency and taste, the duo made their own sex life the subject of several works. They drolly remade the book *The Joy of Sex* with drawings featuring themselves as the protagonists of the sex manual. Fittingly for their Freud Museum show, they put sexuality and consciousness at the heart of their work. *Black Narcissus* (2006) was created using casts of Webster's hands and Noble's penis, and when illuminated creates a double portrait of the artists. Webster drily said their work was *'your worst nightmare of what art can be'*. However, for all their goading provocations and incitement

to reject them, it is not sex and anger that fuel their career, but the concept of love. *The New Barbarians* (1999), a life-size waxwork portrait, transforms the bad boy and girl of the art world into two doting Neanderthals, demonstrating that love has always been central to human experience.

After nearly two decades together and the relationship under strain, it was a kind of desperate love that prompted the pair to marry in 2008. Unsurprisingly, their wedding party was like a work of art in itself. It was held aboard the *Queen Elizabeth* on the River Thames, and fellow artist Tracey Emin conducted the service. But within four years, Noble and Webster had split. Noble confessed: *'We were so locked into one another that we needed something to blow us apart.'*

Too intense, too antagonistic and too passionate, they sacrificed their failing relationship to save their art. Their 2012 exhibition in London was titled 'Nihilistic Optimistic'. They were already separated and the paradoxical terms expressed both the contradictory nature of their practice and, more poignantly, their raw emotions about ending a long public romance. Even in the darkness of the split, Webster was thinking of their art – *'something new will come out of it'* – and Noble too: *'It's always interesting to turn your life upside down.'* Entering the uncharted territory of living independent lives, the artistic duo are making a new body of compelling work and exhibited together in 2017. For now nihilism has given way to optimism.

Always on the boundaries of decency and taste, Tim Noble and Sue Webster even used six months' worth of studio rubbish to create their art.

Idris Khan

&

Annie Morris

2007–present

The British artists Annie Morris and Idris Khan have been married for nine years but could easily have already spent more time with each other than a couple married for a lifetime. They are, as they put it, *'with each other 24 hours a day, every day'*. They share a home and two connected studios in London, they know each other's practice as intimately as their own and have two children together. Even when travel forces distance between them, they never go more than several hours without speaking on the phone and have only ever been apart for more than a week on one occasion. They are intensely part of each other's world, in a manner completely foreign to most marriages. They may share a life in a profoundly connected way, but as independent artists they produce extremely divergent art.

Khan's work is conceptual, largely monochromatic and mainly created using industrial materials, such as glass, steel and subversive photographic techniques. He is well known for his composite images created by

Idris Khan

appropriating one source material, such as scanning every page of the Quran and presenting it as one impossibly densely layered image. Conversely, Morris' work, such as her large tapestries that bring to life her innate gift for free line drawing, is a celebration of line and colour and centres on more traditional media. Khan's world is fundamentally darker, more abstract, more restrained than Morris' visions of abundance, figuration and colour. Everything Morris creates is compulsively touchable; her work makes the viewer want to reach out and feel, whereas her husband's layered conceptual art engages the eye and mind in a journey of perception. Morris' language is intuitive and expressive; Khan's is ordered and disciplined.

The biographies of the artists also reveal striking differences. Morris, a natural bohemian, grew up in London in a Jewish cultured family. Her mother, born in New York, worked as a stage manager and became best friends with the playwright Israel Horovitz, who is now Morris' godfather. Khan's Muslim Pakistani surgeon father met his Welsh mother, a nurse, in Cardiff and he grew up just outside Birmingham in a house with no art on the walls. Morris was practically born drawing and has never not made art. Khan came to his creativity later in life, having committed himself first to long-distance running as a teenager. Forced to give up athletics, Khan studied photography in Derby before gaining the courage to apply to the Royal College of Art in London, which *'absolutely changed everything'*. While Khan was still running miles every day, Morris was spending time in Hampstead with a self-taught potter, who lived a life of pure creativity and became a vital role model for her. Morris later studied in Paris at the Ecole des Beaux-Arts. She lived the Parisian dream, spoke French, and had a totally different kind of education. Khan jokes that she *'sat around smoking, looking at one artwork for hours and nodding'*, whereas in London for him things were less romantic and more practical and he learnt how to talk about his own work.

Their differing backgrounds, education and approach to their practice makes it all the more surprising to learn that they fell in love at first sight, moved in together after a few weeks of dating and were engaged after five months. Their art may have two very different narratives, but their relationship is the stuff of a great vintage love story. Khan was introduced to his wife by a mutual friend who showed him a picture of Morris in *Vanity Fair* and predicted they would marry. They met in September 2007, when Khan attended Morris' solo show opening. He sat next to his future mother-in-law at the gallery dinner and Morris' then boyfriend took the first ever photograph of the pair, the very night they met at Bar Italia in Soho. The image was a premonition, depicting them with heads bent together, locked in deep conversation.

Their wedding in 2009 was at Morris' godmother's house in the South of France, with a faux rabbi, Horovitz, and a faux mullah, Khan's father. The year after the wedding, the romantic wave they had been riding cruelly brought them crashing down and had serious ramifications on their lives and their art. Their first child was still born and months later Khan's mother died. The double tragedy took the newly weds to a bleak place of heartbreak and despair. In the studio, Khan began writing as a form of release and developed

Annie Morris' complex stack sculptures, backed by Idris Kahn's distinctive stamp paintings.

Annie Morris

his stamp paintings, using a small stamp to print text repeatedly until the words became indecipherable and the form abstract. The steady act of repetition was a form of release and catharsis for Khan. Morris' work also developed as she cocooned herself in her studio next to Khan's. Her solo exhibition, 'There Is a Land Called Loss' (2012), was a deeply personal journey through grief, pain, despair and ultimately hope. In her looping instinctive hand, she conjured a reoccurring motif of a single female figure and both drawn and sculpted ball shapes.

These symbols have stayed with Morris, refashioned into fecund embroidered figures and totemic fertility stacks, large balls of pure paint pigment incongruously balanced vertically upon one another. Her language is boundless and almost automative; one gets the impression that these images course through her body like a distinctive electromagnetic pulse. Khan's stamps have also carried him into a new terrain of stamping his favourite poetry and philosophy. An entire book by Theodore Roethke might exist as one large abstract shape with a fixed point, with layered lines emanating from its centre, creating an explosion of words as if the writing is a bullet penetrating the brain. Khan took the notion of repetition and appropriated poetry into the most ambitious work of his career to date. In 2017, he created *Oasis of Dignity,* the first war memorial park for fallen UAE soldiers and citizens, covering an area of 46,000 sq m. The repeated forms of 23 giant tablets inscribed with poetry lean precariously against one another, a metaphor for loss and resilience. The memorial is the complex expression of Khan's subtle interplay between language, culture, abstraction and personal narratives.

Morris and Khan take different aesthetic routes, but closer consideration reveals that at the heart of each of their practices is a shared investigation into legibility, mark making and personal memories, as well as an expression of their private passions. Khan's work is dense and thick, created by endless hours of repeating the same gesture, meditatively scanning or stamping. Morris' expressive work is contemplative in an alternative fashion, less repetitive but equally persistent in creating rich, layered imagery but in a visual landscape with more space and pauses.

Over the past decade, the artists have noticed that small pieces of advice, combined with the magical osmosis that takes place between two connected art studios, not to mention a shared life as a couple and as parents, have led to an undercurrent of influence from the other. Khan's tide of order and patience has swept into the shores of Morris' studio; on his insistence, she is more disciplined about beginning work on a fresh surface rather than compulsively mark making on a dirty floor or page. She also credits him with enabling her to vocalise where her art stems from. Morris transmits back an important message to Khan's studio, that of colour and new media. It was partly her influence that helped him move away from his largely photographic practice into a terrain with less formal and practical constraints. Gently, respectfully and almost unknowingly, the pair are making a vital impact on the other's work. Khan is Morris' editor and conservator, while she in turn leads him beyond the finite into the limitless.

Both still in their early 40s, the couple are on the younger end of the London art world spectrum and it is a tantalising prospect to see how their individual careers will further develop. In their home sits a framed text by Marina Abramović, which reads: *'An artist should avoid falling in love with another artist.'* They like this so much because they both disagree fiercely with her position. They see it as a great privilege and exceptional gift to share their world with another artist, and celebrate and honour their differences. In making art, Khan may be primarily led by the head and Morris by the hand, but they are entirely locked together in their hearts.

Thousands of small individually painted pegs of the naked female form are combined to make one large artwork in Annie Morris' Untitled Peg Piece.

Annie Morris

Index

Acknowledgements

Writing this book has given me enormous pleasure. I have loved getting to know more about some of my favourite artists and discovering a few fascinating names that were new to me. Despite it being such a privilege to write this, it has also been extremely time consuming in an already very full life. So, my biggest thank you is to my magnificently kind and patient husband, James, who listened to these stories, helped me with research, read with enthusiasm and, memorably, batch-made some righteous chilli to ensure I would not go hungry. Jenny Harris, my SG, gave me endless encouragement and feedback, and in a rare weekend off in Barcelona she helped me completely recharge my batteries. Crucially, she bought me the book *Modern Women* (also published by Quarto) for Christmas before I knew I would be writing this, and Kira Cochrane's great essays helped me focus and provided motivation for my own book.

Thank you to my parents Woody and GJ for being a fine love story yourselves, never suggesting I take up a more sensible career and allowing me to follow my lifelong art addiction. And to Gino Ginelli, Timotei, Zoetei and Mikey D, I thank you but mainly wanted to see those names in print. To Tim and Liz Bryan for being forever calm and reassuring as well as for reading some early drafts. To Annie Morris and Idris Khan, my dear friends and a worthy subject of a chapter in this book, thank you for sharing your story with me at your kitchen table and making art that makes me so happy. To Sue Webster, thank you for sending such a positive note about the chapter featuring your work; I respect our friendship enormously. And to my dear friend Dr Prof Thomas Girst who shared the same book deadline, which was comforting, and gave such valuable feedback on the Duchamp and Martins chapter. And to the twins Tom and Jude Capper for providing me with an excellent focus on several weekends. Knowing I would get to play with you made me work so much more efficiently early on Sunday mornings.

I owe a huge amount to my brilliant editor Anna Watson at Quarto, who made this painless, enjoyable and always exciting. I am so glad I took you to the Groucho Club first. Speaking of clubs, I must thank everyone at Soho House for making me so enthralled by my day job running the art collection that I was mad enough to take on this book, too. Also at Quarto, I would like to express my sincere thanks to the project editor Joe Hallsworth and the designer Isabel Eeles. I am so happy with the incredible artwork created by Asli Yazan for this book, allowing us to re-imagine art that spans over 140 years in your distinctive, confident hand. Thank you; you have made this book a work of art.

Finally, I dedicate *The Art of Love* to all artist couples everywhere. I hope you especially treasure these stories of a very special love.